Photographic Composition

Photographic Composition

A Visual Guide

Richard D. Zakia

David A. Page

ELSEVIER

AMSTERDAM • BOSTON • HEIDELBERG • LONDON
NEW YORK • OXFORD • PARIS • SAN DIEGO
SAN FRANCISCO • SINGAPORE • SYDNEY • TOKYO
Focal Press is an imprint of Elsevier

Focal Press is an imprint of Elsevier
30 Corporate Drive, Suite 400, Burlington, MA 01803, USA
The Boulevard, Langford Lane, Kidlington, Oxford, OX5 1GB, UK

Library of Congress Cataloging-in-Publication Data
Application submitted

British Library Cataloguing-in-Publication Data
A catalogue record for this book is available from the British Library.

ISBN: 978-0-240-81507-7

For information on all Focal Press publications
visit our website at www.elsevierdirect.com

10 11 12 13 14 5 4 3 2 1

Printed in Canada

Typeset by: diacriTech, Chennai, India

To Professor C.B. Neblette, who in 1927 had a dream that photography should be part of a college curriculum. He saw his dream come true when in 1936 he became the director of a fledgling photographic program. With support from the Eastman Kodak Company, he developed the program into the largest in the nation. It is now called the School of Photographic Arts and Sciences at the Rochester Institute of Technology.

Richard D. Zakia

To Duke University's matriarch, Mary D.B.T. Semans, who for decades has been the guiding force behind the Visual and Performing Arts at Duke University and the North Carolina School of the Arts. Duke's first digital imaging computer, a Mac 660AV in 1993, was funded by her, which ushered in the digital photography age on campus. She also supported and funded many other photographic efforts and activities at Duke.

David A. Page

CONTENTS

CONTENTS

CONTENTS

ACKNOWLEDGMENTS

We are grateful for the many friends and colleagues who have allowed us the generous use of their copyrighted photographs. Without them, we would have been limited in the number of diverse photographs used in our book. Their names accompany their photographs. Where there is no

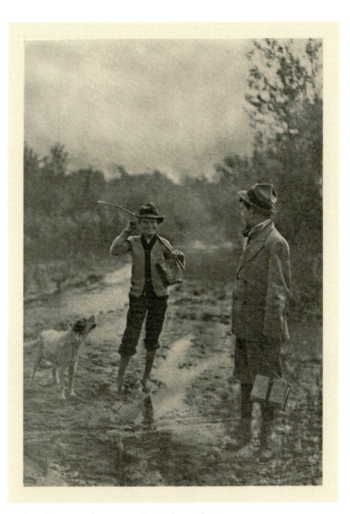

Let's Play Hookey, 1911 by Edward Weston

Every artist is at first an amateur. Peter Henry Emerson

listed authorship of a photograph, it is from iStock. We appreciate the vast diversity of their imaging resources. We are also grateful to Dover Publications for making available copyright-free high-resolution historical photographs and paintings. A special thanks goes out to Vicki H. Wilson, not only for the photographs she contributed but also for many different ways she so graciously assisted us, including some writing. Thanks also to our editor, David Albon in the London office and in the Boston office, Cara St. Hilaire, Kara Race-Moore, Stacey Walker, and Project Manager Melinda Rankin. It was indeed a pleasure working with them.

INTRODUCTION
Photographic Composition Visualized

Composition is the strongest way of seeing. Edward Weston

INTRODUCTION

Digital photography has opened the door for everyone to become a photographer, and to discover, enjoy, and record the beauty that surrounds us. No longer is the pursuit of photography mired in the technical. "Point and shoot" is now the equivalent of Kodak's early box camera tagline: "Press the button and we do the rest." The ease, fun, and satisfaction of truly instant digital photography have made us all photographers: Point, shoot, and share.

Although digital technology has simplified the technical aspects of taking photographs, it has done little to help us in the composing of photographs. Our book provides guidelines for improving the arrangement of elements in a photograph so as to create a sense of structure and balance. One might think of it this way: composition is to photography as grammar is to writing. Both need structure.

COMPOSITION

An article in a recent photographic magazine began with a statement that everything photographic begins with an understanding of the technical aspects of the equipment being used, such as the camera, lens, and filters. We agree somewhat, but would add "not everything." Of equal importance is the capture of the photograph, which suggests some knowledge of composition. In mastering composition, one must develop the ability to attend to and see the shapes and forms of objects, textures, lines, masses, and the like, as well as their relationship to each other. This book emphasizes the importance of composition in both the taking of a photograph (capture) and making any adjustments that can improve the photograph after it has been taken (after capture).

Most photographic books that address the need for composition do so in a limited way. This book, on the other hand, is completely dedicated to a comprehensive approach to this important subject. The term "photographic composition" is most often used to define a small set of strict rules, such as the "Rule of Thirds," that can strengthen the structure of a photograph. We have extended the range of compositional features to incorporate such things as the need for clarity or ambiguity in a photograph, practical examples of portraiture, the use of light and shadows, morphs

(the discovery of different shapes and forms in nature), and Gestalt principles of organization from the field of psychology.

> Composition should be a constant preoccupation ...
> an organic coordination of visual elements. Henri Cartier-Bresson

BALANCE

One of the underlying features of good composition is balance—*visual balance*. Visual balance is different than physical balance, which is determined by mass—the weight of an object. The things that give an object visual weight are its tone (darkness, lightness), shape, form, size, visual importance, and placement within the frame of the photograph. It is also the reason that professional mat boards are wider on the bottom than on the top, as seen here. Usually the color of the board is neutral (white, gray, or black) but in this case the photographer chose a blue color to complement the blue on the racecar.

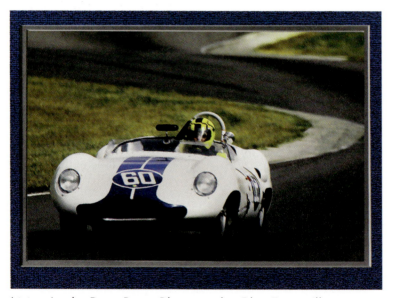

Lister Jag *by Dave Page. Photograph 1. Blue Frame Illustration.*

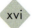

Balance is basic to all of our human endeavors, not just the visual. Biologically, we feel our bodies are in balance thanks to what is called *homeostasis*. It is the ability and tendency of the cells in our body to maintain an internal equilibrium—a balance.

In Native American languages, the word for "balance" and the word for "beauty" are the same. Leslie Gray

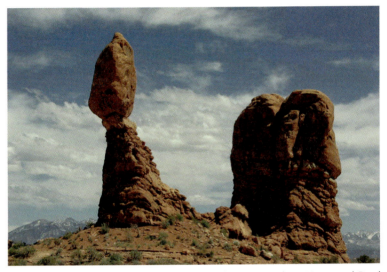

Balancing Rock, Utah *by William Scanlon. Photograph 2. In Arches National Park, one huge rock sits delicately and precariously balanced a top another.*

Our visual sense of balance is very much determined by our man-made surroundings. We expect everything to be vertical or horizontal: buildings and homes (inside and outside), road signs, and the like. If things are tilted, we tend to feel an imbalance—some of us more than others. It is not surprising that all of our senses require balance: auditory (music), olfactory (food and fragrances), and kinesthetic (body). Balance is basic to all human experiences.

Human beings are psychologically disturbed and often deeply upset by imbalance, disorder, chaos, tension, and conflict. Jack F. Myers

Leaning London Building. Photograph 3. This tilted City Hall building in London contrasts against the two straight uprights of the London Bridge. The tilt causes a visual tension, a disequilibrium, which can make some people uncomfortable and some even nauseated. We depend, in part, on our visual field for balance. (Visual field dependency.)

EMPHASIZING THE VISUAL

You will be pleased to find in this book an emphasis on the visual, of first showing what we are talking about, and then a few words of discussion. Every page in the book has a picture accompanied by a short explanation. In effect, the book is a picture book of compositional features. One can learn from the book without being well versed in English.

As you go through the book, you will recognize that we have built in some meaningful redundancy as a way of clarifying and reinforcing what we are presenting. It is the visual equivalent of the familiar verbal statement we use when we are trying to explain something in another way: "in other words." "With other pictures," we hope to do the same.

Another feature of our book is the use of photographs taken by earlier photographers, such as William Henry Jackson, August Sander, Alfred Stieglitz, and Nadar. These photographs provide the serious photographer with a connection to the richness of the past. You will also find photographs by current professional photographers and those from other walks of life who have taken up photography as a hobby and means of personal expression. Some are teenagers and some are

senior citizens. Digital photography provides us all with a way of creating pictures with light. We hope our book will provide a way of improving your photographs by attention to composition, which provides the unifying structure in a photograph.

At the end of each chapter, we have included some exercises for those interested and for teachers who may be using this book for instruction. The exercises in each of the sections are in two parts. The first part is called "Looking," in which the reader is directed to look at and study some photographs in books and on the Internet that relate to the topic presented—"learning by looking." The second part, "Photographing," consists of shooting assignments to provide the opportunity for practical hands on experience—"learning by doing."

TWO QUESTIONS

In the preparation of our book, two general questions were addressed:
 1. What compositional guidelines would be most helpful but not overwhelming? In other words, what falls into the military categories of "need to know" and "nice to know"?
 2. What is the best way to present these guidelines?

The second question was easier to address than the first. Because photography is a visual medium and the emphasis is on the visual, we must *show* what is being presented. To accomplish this, a picture appears on each page with a few words: look, learn, and enjoy.

We have included a number of quotations throughout the book that we feel are relevant. Think of them as visual sound bites and as words of wisdom; as Benjamin Disraeli reminds us, "The wisdom of the wise and the experience of the ages are perpetuated in quotations."

The book is divided into three sections:
 1. Before Capture (The planning stage.)
 2. Capture (Taking the photograph.)
 3. After Capture (Adding captions, Changing the aspect ratio, and Using image modification tools.)

Photography has not changed since its origin except in its technical aspects which for me are not a major concern. Henri Cartier Bresson

SECTION ONE: Before Capture

Before Capture

It is helpful to give some thought to what you want to photograph before going out to do so. Both physical and mental planning are important when preparing to photograph.

Physical Preparation: Besides preparing the needed equipment such as cameras, lenses, filters, and the like, thought must be given to what you intend to photograph: nonaction (landscapes, flowers, portraits, antique cars) or action (sports, kids at play, motion). For example, in photographing a person, many a fine portrait has been diminished because the person to be photographed got bored waiting for the photographer to get ready, which includes such things as selecting the background, type of lighting, camera lens, and filter. All preparation should be taken care of before the person is positioned to ensure the desired result. The first few seconds of a portrait session are golden. Relax your subject. Some photographers play music in the background to help relax the person.

Rick Sammon, author of many books on photography, has his own method for relaxing people before photographing them. He spends time with them before photographing, engaging them in conversation, telling jokes, and performing some magic tricks to entertain. It has worked well for him.

When Vicki Wilson decided to do a Vermeer-like photograph (subject bathed in soft window light), she planned well ahead by first reviewing the many Vermeer paintings on the Internet. She and Missy discussed the location, props, wardrobe, and what Missy would be doing (implied action) while being photographed. (See page 197) A two-hour block of time was reserved for completing the assignment.

When photographing a landscape, time of day becomes important, because it will determine the direction and quality of light available (bright sun, cloudy, hazy). Realize that even with planning, atmospheric conditions might change. Don't overlook the opportunity to capture the unexpected. It is amazing how photographing in a mist or during and after a rain can add mood and substance to the image. When Ansel Adams photographed landscapes, he always attended to the sky to make sure no birds were in flight, as they would be recorded as white specs of dust on the negative and black specs on the print.

Roy Stryker, who headed up the important photographic operation of the Farm Security Administration (FSA) in 1939, would make specific assignments for his photographers. In his "General Notes for Pictures Needed for Files" he would list such things as small towns, signs, farms, industry, people, and so on. Photographers such as Dorothea Lange, Russell Lee, Walker Evans, Gordon Parks, and others would carry out their assignments but would also keep an eye open for unassigned opportunities.

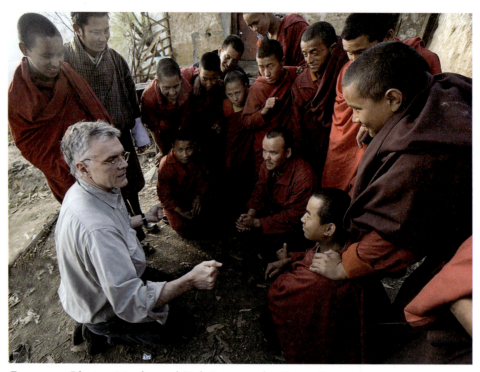

Figure 1.1. Bhutan Monks and Rick Sammon by Susan Sammon.

There are times, however, when it is fun and most enjoyable and relaxing to just go out to a new location and photograph whatever interests you at the moment and then study it later. Although new locations can be stimulating so can familiar ones. Some years back, when Bea Nettles was teaching at the Rochester Institute of Technology (RIT) while pregnant, she was not able to do any traveling. She decided to stay around the house and take photographs of her flowers and other things—with great success.

Mental Preparation: In addition to physical preparation, some photographers spend time getting into the right frame of mind before setting out to photograph. Edward Weston, for example, spent time listening to the music of Bach. He attests to this in his diaries (edited by Nancy Newhall). He mentions that when he hears Bach, he is deeply moved and feels his influence. Music and photography were closely linked for Weston, as they were for other photographers—some of whom happened also to be musicians, such as Ansel Adams, Paul Caponigro, Carl Chiarenza, and George DeWolfe. Weston's remark that when he hears Bach in his photo he knows that he has succeeded, suggests that he may have had a *synesthetic* (the ability of one sense to trigger another) experience.

A PBS program on "Music and Science" broadcast in June 2009 pointed out how music stimulates our imagination, that it has certain emotional characteristics, and that music can change our state of mind.

There are many ways to prepare the mind prior to photographing. Some prefer listening to music, some playing music, some reading poetry, some praying and meditating. Minor White, for example, practiced Zen; Duane Michals and Paul Caponigro followed Buddhism. Sometimes things can work in reverse. Prayer can help in preparing to photograph and photography itself can also be a form of prayer. A friend who is a Jesuit priest and a prominent photographer once told me that for him photography was a form of prayer.

Some photographers have found "mindfulness" helpful. George DeWolfe, in a personal note, wrote, "I use Mindfulness because it puts me here, right now, with a calm and aware mind. … It doesn't so much guarantee you a great photograph, but it puts you in a place where you can see one. … Above all, I think the main motivation is the love of photography itself—the passion. It is the power that propels us to picture the world we see."

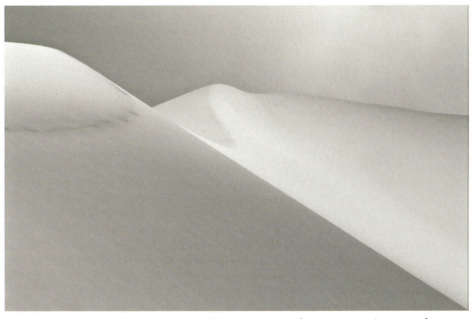

Figure 1.2. I saw and photographed this moment of mystery and grace of the Eureko Dunes in Death Valley in an instant of authentic recognition and response. George DeWolfe.

SECTION TWO: Capture

Geometrics

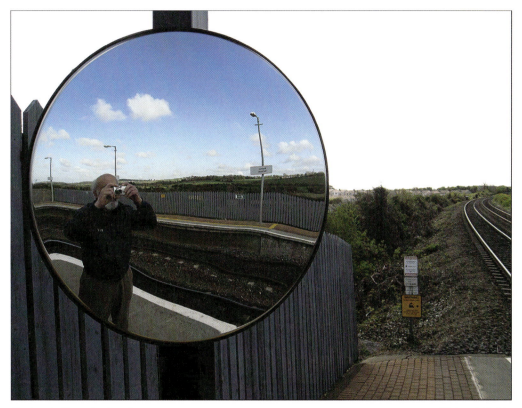

Train station, Ireland *Richard Zakia*

Rule of Thirds: Imagine the photograph you are about to take as having superimposed upon it four imaginary lines spaced equally apart. Two are horizontal and two are vertical. If you are photographing only one subject and place it at any one of the four intersecting lines, you will, in most cases, have a balanced photograph. If the subjects are sitting or are small children standing, the lower intersecting points could be used. When considering where to place a horizon line, the top or bottom horizon line would work well, depending upon the subject matter. The rule of thirds is a popular and practical compositional consideration device. Rules such as this were in use by painters in the nineteenth century.

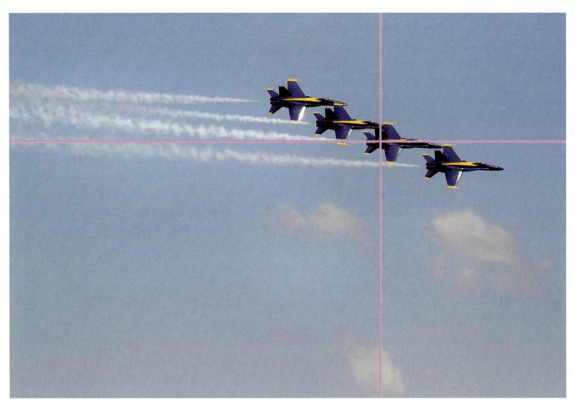

Blue Angels *Vicki H. Wilson*

The Navy planes performing their air show in Louisville, Kentucky, presented an interesting compositional challenge. Normally, one would want to have more distance in front of the planes than behind. Here, it was decided to include the smoke trails to suggest speed. The puffs of clouds just below the planes provide interest and balance. All of these quick visual decisions were made as the Blue Angles zipped by at over 200 mph. The dark blue color of the airplanes with a yellow trim helps them stand out against the lighter blue sky. The diagonal formation of the planes provides a dynamic arrangement that plays well against the horizontal smoke trails. Their first exhibition flight was in June 1946 at their home base, Naval Air Station, in Jacksonville, Florida.

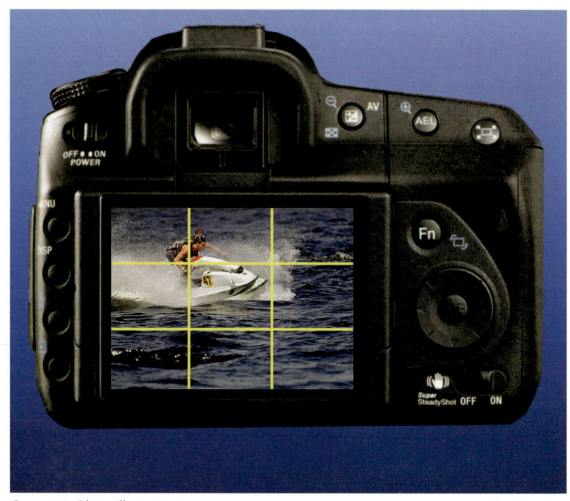

Composite Photo-Illustration *David A. Page*

Many of today's digital cameras come with a rule of thirds pattern that displays on the viewing screen on the back of the camera. This can be helpful in framing your photographs. Here, the capture of the subject is well placed in a position at the upper-left intersection of the grid. It could have also been placed at the upper-right intersection, but this would not have given room for the boat to move speedily within the frame of the photograph. Consider how the speeding boat might have looked at the lower intersecting points. A fast shutter speed and panning the camera with the boat was necessary to avoid blur and capture a sharp image.

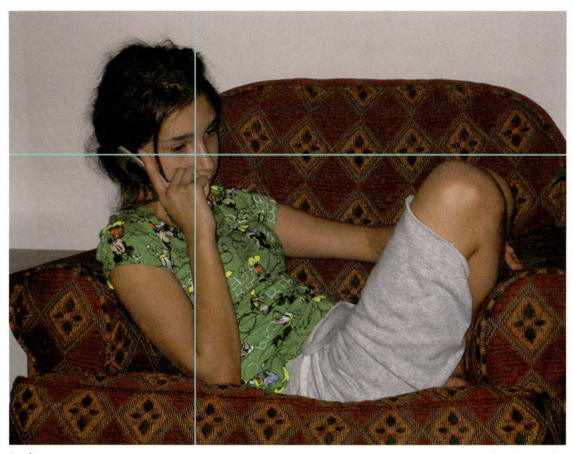

Lydia *Richard D. Zakia*

A typical teenager with a cell phone is crouched in a soft, comfortable chair and is unaware that she is being photographed. Her head is nicely positioned so that it falls in the upper-left intersection of the rule of thirds. The color of her green blouse is given emphasis by the dark reddish chair in which she sits. The diamond-shaped patterns in the chair work well against the plain grayish background of the wall. Had there been a plant or some other object in the background, it might have drawn attention away from the main subject.

The most I can do for a friend is simply to be his friend. Henry David Thoreau

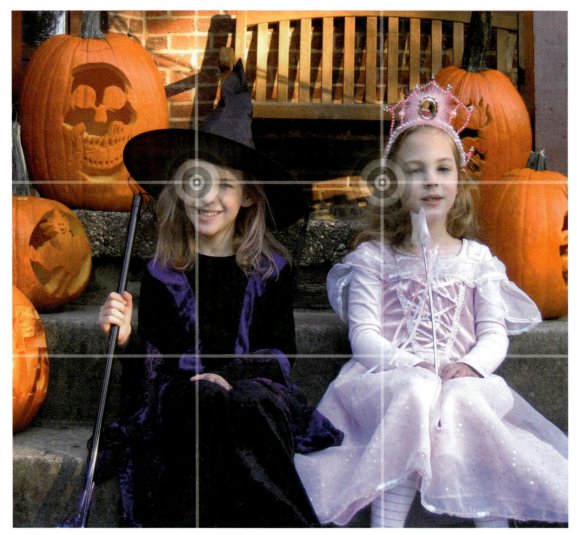

Target Area

Think of the intersecting points of the rule of thirds grid, not as a point but rather as a target area. Although Lauren and Molly are not positioned at the exact grid intersection, they are on target, providing a well-balanced photograph. Being overly concerned with placing your subjects at the exact intersection or vertical lines can impede your photographic efforts and take the fun out of photography. Insisting on a perfect positioning could cause the girls to get anxious and a bit frustrated, which could destroy some of the spontaneity of the pose.

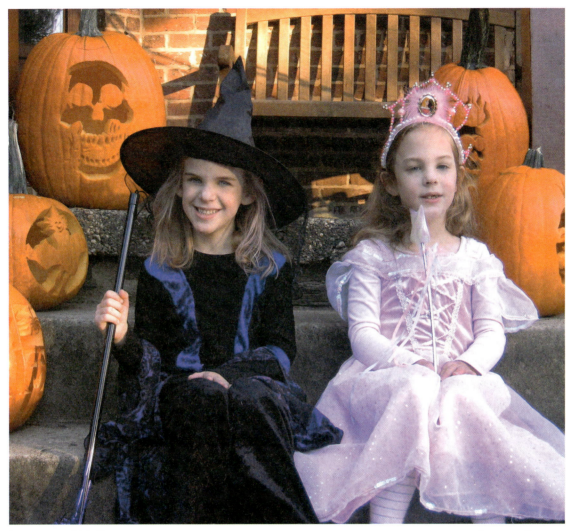

Lauren and Molly *Susanne Conway*

The twin sisters sit quietly and attentively for this Halloween photograph taken by their mother. The two girls are at ease and seem to enjoy having their picture taken. They each chose their own costume, which reflects two distinct personalities.

A picture is the expression of an impression. If the beautiful were not in us, how would we ever recognize it? **Ernst Haas**

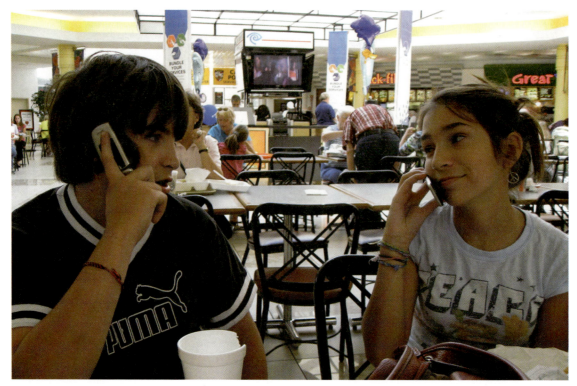

Liam and Lydia *Richard D. Zakia*

This scene is a typical one: a food court in a mall and two teenagers at lunch, playfully using their cell phones to chat. Their two faces follow the rule of thirds in the horizontal direction but not in the vertical direction. The distance between them seems to be one with which they are both comfortable. Had they been asked to move so that their heads would fall along the vertical intersection of the grid, the photograph would be less intimate and the spontaneity of the moment lost. From the looks on their faces, they are not just posing but are actually carrying on a conversation. The photo can be read as a parody of our over-dependence on cell phones.

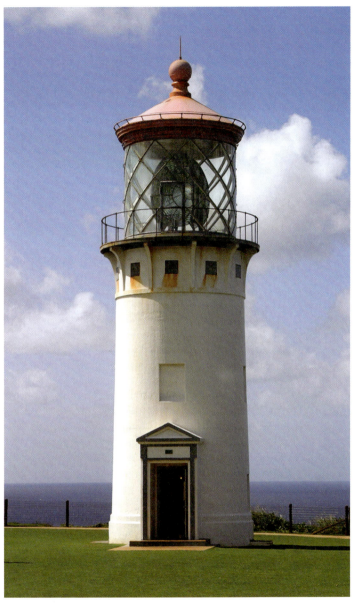

Hawaiian Light House *Vicki H. Wilson*

Centering: Sometimes centering an object, such as this lighthouse, is the right thing to do. Its strongly centered vertical lines are counterbalanced by horizontal lines of grass and sea and a beautiful blue sky.

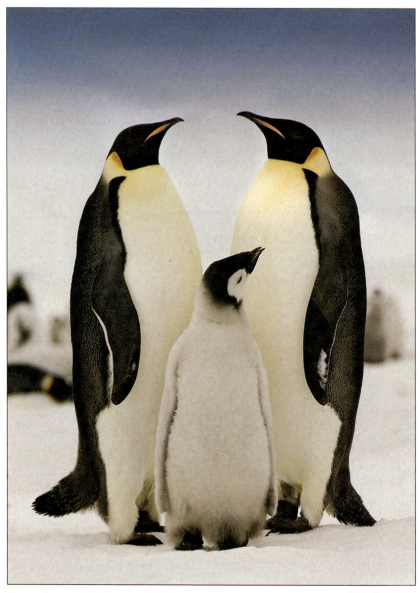

Penguins *Rick Sammon*

Centering a photograph can be quite acceptable, depending upon the subject matter. If the penguins were a bit off to the right or to the left, the photo would appear unbalanced.

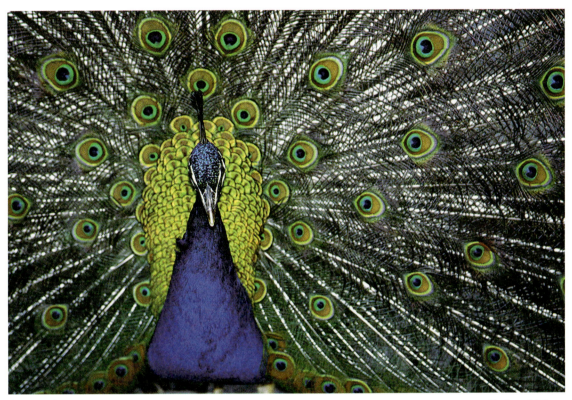

Peacock *Fatima NeJame*

Off Center: The blue-feathered body of the peacock is not centered and is off to one side, close to the left vertical line of the rule of thirds. This is more interesting than having the bird placed dead center. Fan-like feathers of the bird completely fill the frame, providing an uninterrupted colorful background. The iridescent blue and green colors are a result of optical interference similar to what we see in an oil slick on water. It is the male peacock that displays such brilliantly colored tail feathers. The female has a mixture of dull green, brown, and gray. The yellow feathers that surround his blue body provide a strong color contrast.

I am not interested in shooting new things—I am interested to see new things. Ernst Haas

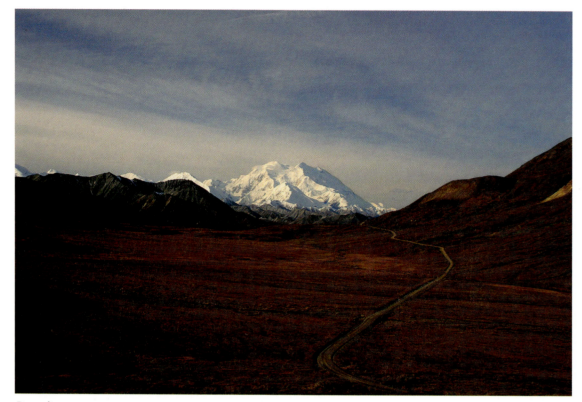

Denali

Bill Stanko

Lead Line: The serpentine lead line meandering through the brownish foreground brings the eye to the snow-capped peaks of Mount McKinley, the highest mountain in North America, with a height of approximately 20,320 feet (nearly 4 miles). Its Indian name is Denali (The Great One) and it is the centerpiece of Denali National Park in Alaska. The narrowing lead line provides a dimension of depth, as do the black mountain peaks in the foreground that contrast against the white peaks in the distance. The warm, dark colors in the foreground complement the blue sky and white snow peaks at the end of the trail, which is central to the photograph. Had the photographer chosen a longer focal length lens, the white-capped mountain peaks in the distance would appear larger, but at the expense of a loss in the lovely meandering lead line.

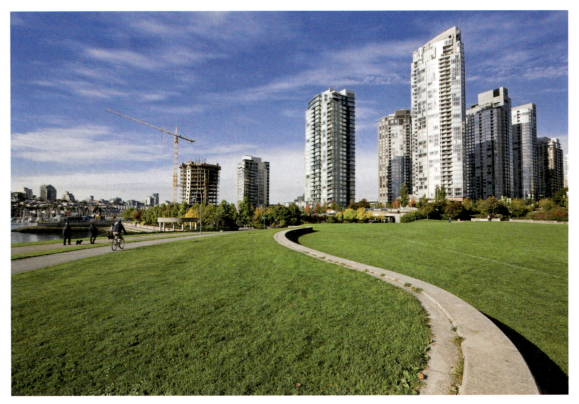

Vancouver, B.C.

S-Curve: The curved lead line directs the viewer's attention from the bottom right of the photograph to the tall buildings of downtown Vancouver. The diminishing width of the line as it curves its way downtown creates a sense of depth. The straight bicycle path at the far left side of the photograph balances the dominant S-shape curve. It is important to the composition that when a photographer incorporates a lead line; it serves a purpose, in this case inviting someone to visually "travel down the path" and be rewarded by an interesting subject at the end of the path. In this photograph, the reward is the majestic buildings and skyline of a great city. To the far left, one notices a building under construction and a very tall crane against a blue powdery sky—a sign of a growth.

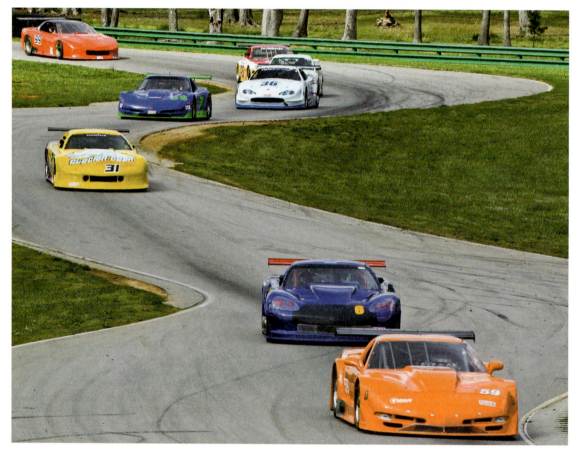

S-Shape Curve *David A. Page*

A 600mm lens was used to capture the colorful racecars on turns five and six at the Virginia International Raceway. This increased the shape of the S-curve by compressing the field of view, which is a useful attribute of a long focal length lens. The colorful arrangement of the racecars provides added interest to the sinuous S-shaped track. The time of the exposure was based on capturing the orange car as the first car, which required considerable planning and patience.

To come up here and just get in the car where there are no telephones and nobody to bother you, you can just run around out there and see how fast you can go. It's just fun. Paul Newman

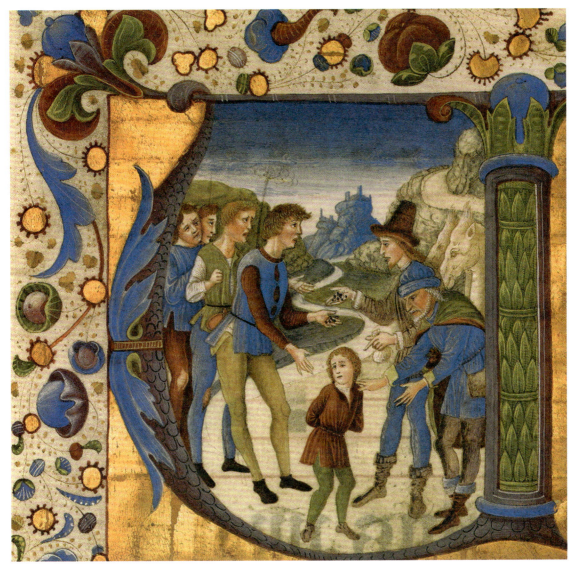

Joseph *Giovanni Pietro da Cemmo (1474–1507)*

"By reviewing the old we learn the new": we see here the use of the S-curve in this 500-year-old decorated painting. Joseph is being sold by his brothers and is the center of interest as the elders discuss the exchange. Illuminated manuscripts are the most common specimen of medieval painting to survive.

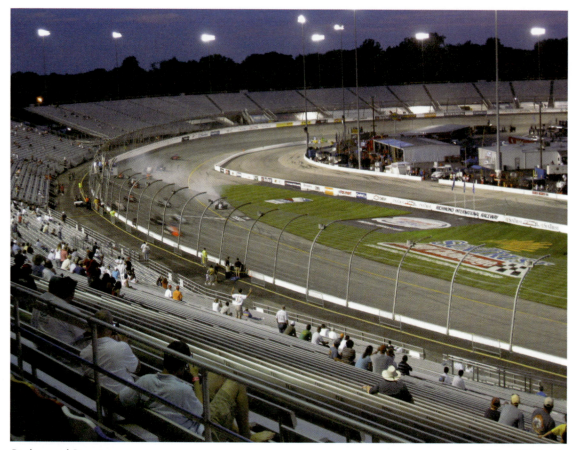

Richmond Raceway *Richard D. Zakia*

C-Shape Curve: This photograph, taken at the Richmond Virginia racetrack, reflects the use of a compositional C-shape curve, which plays well against the straight seat arrangement in the stadium. The action is caught just at the turn when one of the cars begins to spin out, leaving a cloud of white smoke. Additional interest is generated by the dark blue color of the evening sky in the background and the normal colors of the brightly illuminated track.

To photograph is to hold one's breath, when all faculties converge to capture fleeting reality. It's at that precise moment that mastering an image becomes a great physical and intellectual joy. Henri Cartier-Bresson

Blue Ridge Parkway *David A. Page*

Reverse C-Shape: The reverse C-shape curve of the wooden split-rail fence in this snow-covered field on the Blue Ridge Parkway near Floyd, Virginia, leads the viewer's eyes into the muted background. As the fence diminishes in size, it provides an added sense of depth. The curved shape of the fence can be seen as both concave and convex. The concave side embraces the field of snow at the left while the convex side pushes against the snow on the right—much as a sail on a sailboat gathers wind and pushes the boat forward. The bare trees to the left and the grouping of snow-muted trees in the distance add to the feeling of a cold, wintry day.

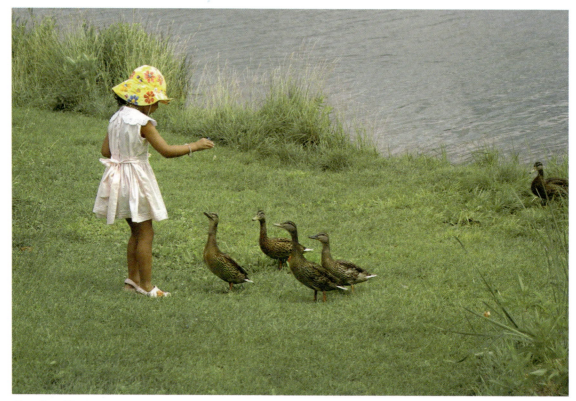

Feeding Time

Bill Scanlon

L-shape: A little girl in a white dress and yellow hat is seen feeding four young ducks at the edge of a pond. Her vertical position is slightly off to the left and her hand is outstretched. It is an interesting composition and photograph. The position of the girl and four ducks suggests an L-shape. The lone mother duck standing protective guard at the edge of the blue pond extends the L. The diagonal shoreline of the pond is greatly preferable over a static horizontal shoreline.

Everything that slows us down and forces patience, everything that sets us back into the slow cycles of nature, is a help. Mary Sarton

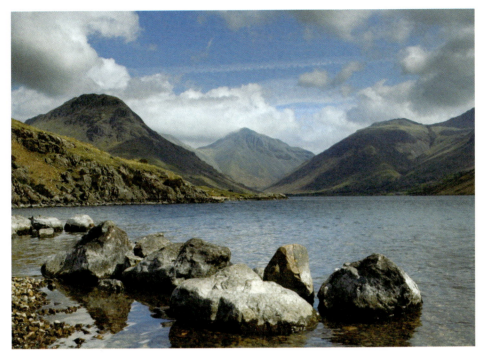

English Lake District

V-Shape: In creating this classic view of the mountains in the English Lake District, the photographer framed his photograph so that the mountain in the background occupied the center position. On either side, there are two sloping mountains. The line that forms the left slope together with the one that forms the right slope make the letter V. A feeling of depth is provided by the formation of rocks in the foreground, the lake in the middle ground, the two mountains in the far middle ground, and the Great Gable mountain in the background.

Mountains are earth's undecaying monuments. Nathaniel Hawthorne

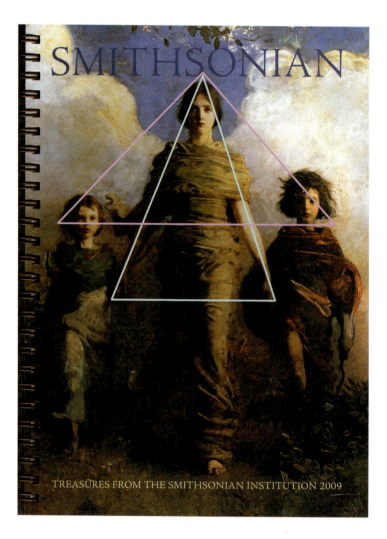

Triangles: Thayer's arrangement of the three figures, the tall goddess in the middle with two small girls on either side, forms a strong triangle. The goddess's outstretched hanging arms form a narrower triangle that gives added strength to the composition. Behind, and on either side of her, is a cloud formation that takes on the appearance of a pair of wings.

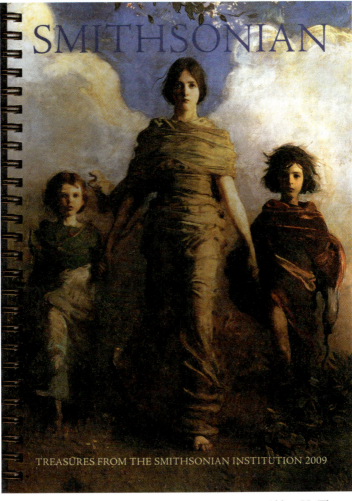

A Virgin *Abbot H. Thayer*

Abbot Thayer was an American artist who at the age of 18 moved to Brooklyn, New York. The central figure in his painting of 1892/3 originally was meant to represent Flora, the Greek goddess of flowers. As she is shown here, however, she represents the heroic Greek goddess Victory.

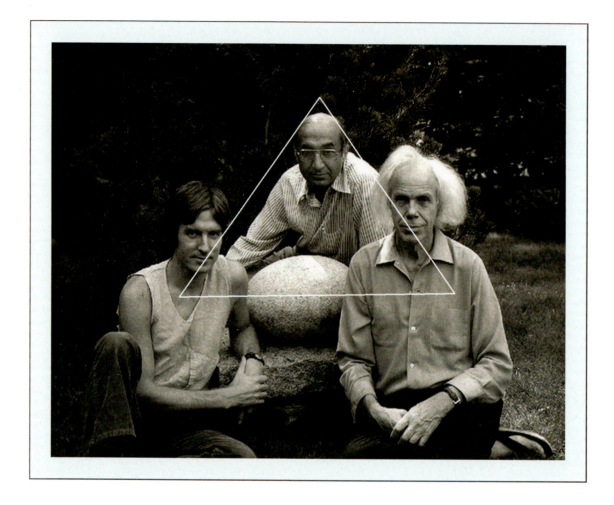

A triangle is a common and useful geometric shape that suggests strength and stability. The pyramids in Egypt are three-dimensional triangles, and in fact can be seen as such if photographed from just one side. Arranging subjects in such a way that they fit into an imaginary triangle is a very useful compositional tool. Triangular composition is basic to many images, not just photographs. One can identify them in paintings, graphic design, and architecture.

Mighty is geometry, joined with art, resistless. Euripides

Three Photographers *Minor White*

This photograph was taken in 1974 in the backyard of Minor White's home in Cambridge, Massachusetts. The tree photographers are positioned around a large egg-shaped stone, which was the centerpiece of his Zen garden. At the time, Minor was teaching photography at MIT. He arranged the subjects as we see them here, and then set his Polaroid camera on a tripod for a delayed time exposure. From left to right are Peter Lorenz, Richard Zakia, and Minor White. The photograph was used on the back cover of their book, *The New Zone System Manual* (Morgan & Morgan, 1976). The original Polaroid print resides in the RIT archives.

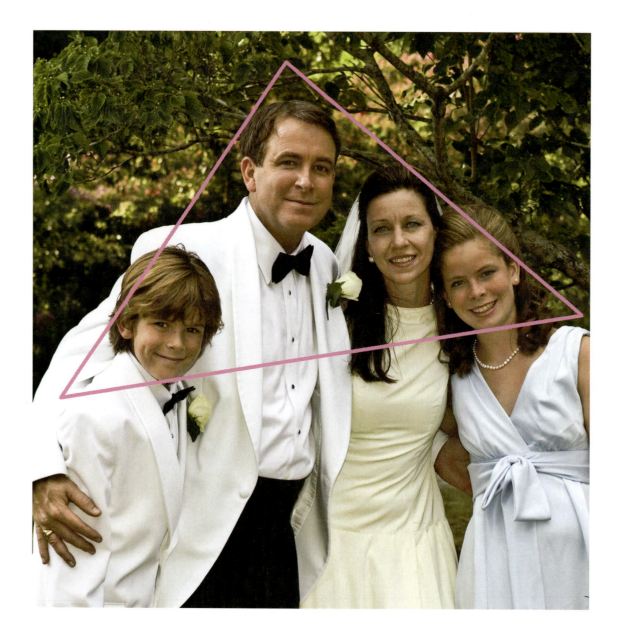

This photograph was taken by a professional wedding photographer. She arranged the group so that their heads all fall into a tilted triangle. There is nothing more boring than a group all lined up with their heads in a horizontal line. She selected a pleasant, out-of-focus background of greens as a backdrop and used a soft fill flash to soften the shadows in the faces.

Summer Wedding *Lee Thompson*

The best man, groom, bride, and bridesmaid celebrate a start of a new blended family. The body language captured by the photographer conveys the affection between the daughter and her new stepmother. The groom and his son show a warm relationship.

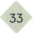

33

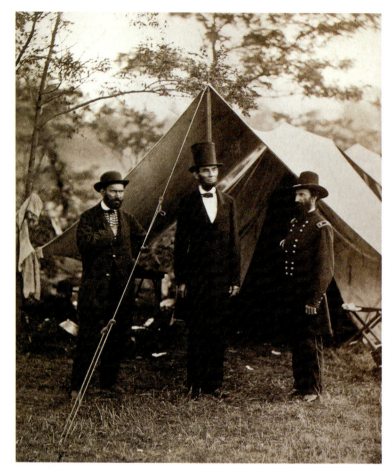

Lincoln at Antietam *Alexander Gardner*

President Lincoln, with his tall stovepipe hat, stands erect with two shorter men at either side. His security guard, Allan Pinkerton, is to the left and Major General John McClernand is to the right. All three men look off into the distance. Behind them, the opening in the tent forms a triangle, and a flatter triangle can be seen by an imaginary connection of their heads. A long exposure time was required to make this albumen photograph. Lincoln had commented to Gardner earlier that he might not be able to hold the pose for the required time and his blurred face shows that he couldn't.

I don't like that man. I must get to know him better. Abraham Lincoln

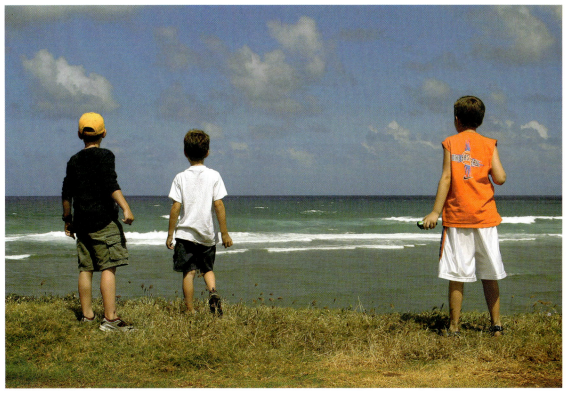

Three Young Boys *Vicki H. Wilson*

Horizon Line: The horizon line here is placed close to the center of the photograph and is interrupted up by the three boys in the foreground. The breaking up of the horizon line keeps the photograph from being static. The arrangement of the boys is such that one is separated from the other two. This provides a more interesting composition than if the three were grouped as one. As you enter the photograph, you have a tendency to look out into the ocean as the boys are doing. If they were facing you, this would not be so; attention would be focused on each boy, making the background secondary.

Simply look with perceptive eyes at the world about you, and trust to your own reactions and convictions. Ansel Adams

35

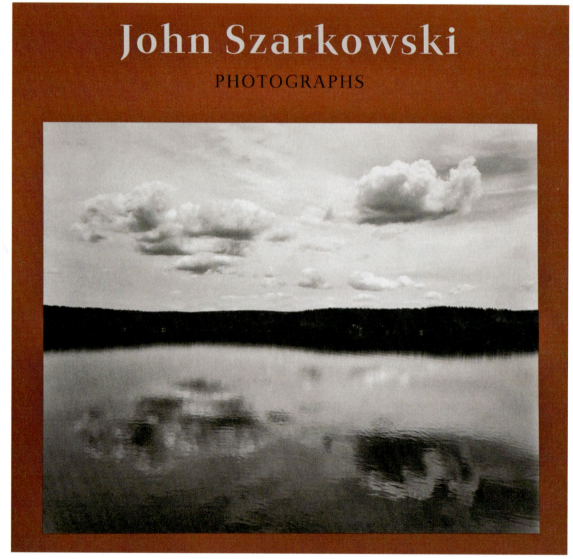

Book Cover *John Szarkowski*

Where to place the horizon line in a photograph can lead to contradicting statement, but one rule is to never place it in the center of a photograph. We see here that the photographer (a former curator of the Museum of Modern Art) chose to locate the horizon line slightly above center of his photograph "Sarah Lake 1962."

Ireland *Richard D. Zakia*

Using a high horizon line in this photograph directs the viewer's attention to the blue car. The uncluttered background provides a serene setting with an empty bench to the left as an invitation to the driver to step out of the car and enjoy the beauty of the quiet blue sea and sky. The three different shades of blue—car, sea, and sky—harmonize well. The photograph was taken in Ireland with the Irish Sea as a background. The American driver seems proud to be able to drive a Peugeot using a steering wheel on the right side.

> I have often been asked what I wanted to prove by my photographs. The answer is, I don't want to prove anything. They prove to me, and I am the one who gets the lesson. Lisette Model

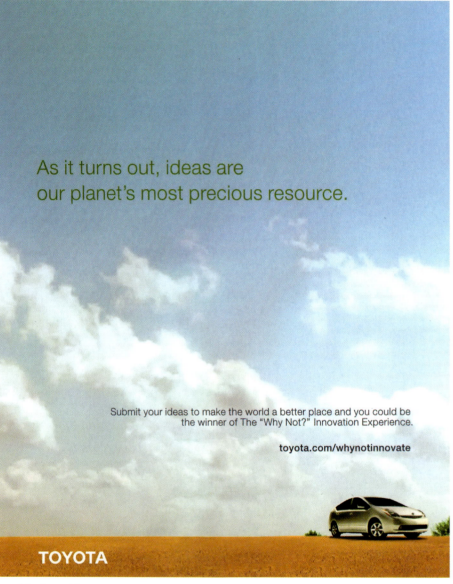

Low Horizon Line

The low horizon line in this ad allows a beautiful blue sky with powdery clouds to occupy nearly the entire photograph. This suggests clean air, fresh air, open optimistic sky, and the future.

Washington Crossing the Delaware *Emanuel Leutze*

Diagonals: The action and drama of this historical event are captured, in part, by four of the diagonal oars pushing away the huge pieces of broken ice. The extended arms and postures of the oarsmen suggest the hardship and danger being undertaken. The American flag proudly flies at a diagonal, with a courageous George Washington proudly standing tall and confident as he looks forward to the engagement. The crossing was on Christmas night in 1776. The semidarkness of the scene accentuates the danger and the drama about to unfold. The painting catches the desperate attempt to surprise the Hessian and British soldiers at Trenton. This important painting is billboard size, measuring, 12 feet high by 21 feet long. It is twice the size as Botticelli's "Birth of Venus." Leutze was a German-born American; he painted this in Germany using the Danube as his river. The painting is an American icon, like the much smaller photograph of the flag raising on Iwo Jima by Joe Rosenthal.

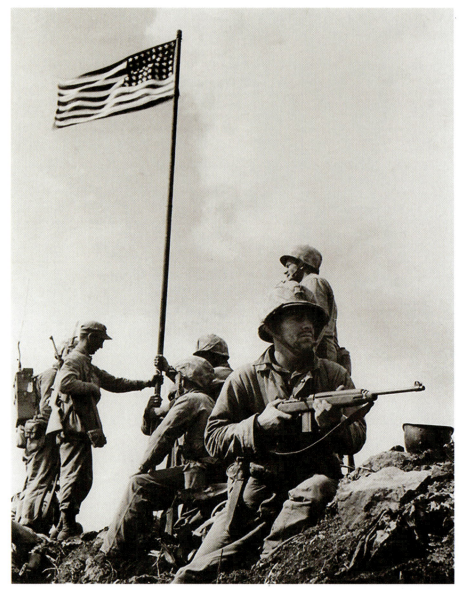

Flag Raising *Louis R. Lowery, USMC*

This photograph taken of the first flag rising on Iwo Jima on February 23, 1945, does not have the iconic impact that the more familiar one has. However, it records a memorable event with the waving American flag standing tall and being protected by the soldier poised with his rifle. It is a powerful photograph in its own right.

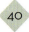

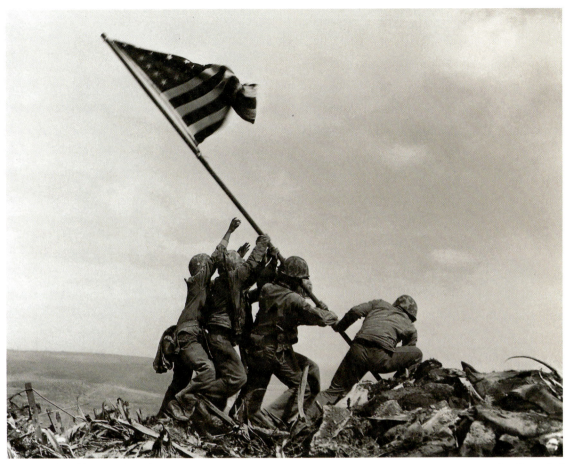

Raising the Flag on Iwo Jima *Joe Rosenthal*

Joe Rosenthal's photograph of the flag raising on Iwo Jima in 1945 has become an American icon. What makes it so powerful as a symbol of embattled patriotism? "The decisive moment!" The angle of the flag is perfect in its rendition of action and suggested movement upwards, as is the ascending motion of the men raising the flag.

I was lucky to catch the flag-raising at its most dramatic instant, producing a masterpiece of composition. **Joe Rosenthal**

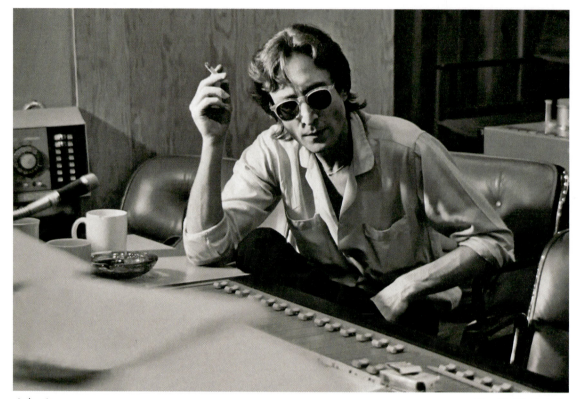

John Lennon *David M. Spindel*

Diagonals and angles play a very important role in this dramatic photograph of John Lennon. If it has been taken straight on, perpendicular to the camera, it would not have the impact it does. This is a studied photograph of a musical artist intensely involved in his work. His body is at an angle to the camera, as is the long instrument panel. His head is tilted and his arms, one resting on the panel and the other on the chair, form additional angles, providing a sense of action and thought. The coffee cup at the left, and the cigarette in his right hand provide a needed break from what appears to be a lengthy session. David Spindel took this photograph and others in October 1980, just two months before Lennon's tragic and untimely death.

Give peace a chance. John Lennon

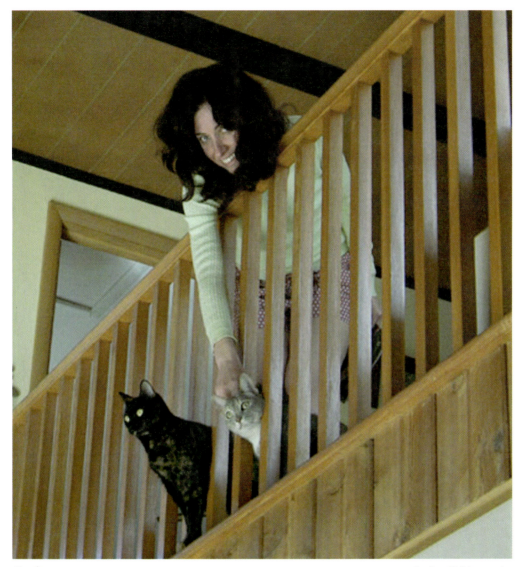

Kayla *Irving Pobboravsky*

Whereas straight vertical lines tend to be static, in this case the strong dynamic diagonal lines moving upwards activate them. A second set of dark diagonals can be seen in the upper background. The photograph is a wonderful composite of verticals, diagonals, and even two triangles in the green area to the left. The hard look of the geometrics is softened by Kayla's gracefully flowing hair and her two inquisitive cats.

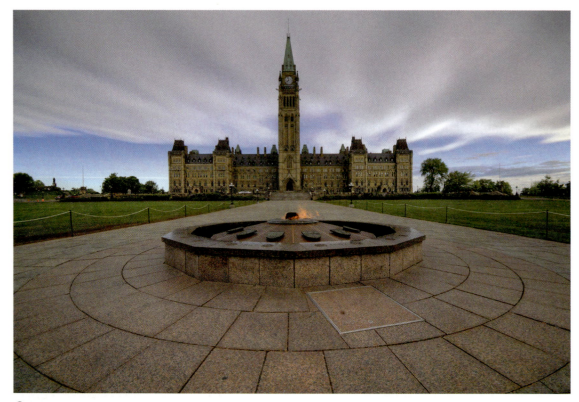

Ottawa

Symmetry: With perfect bilateral symmetry, the visual elements are mirror images of each other. In a photograph, this can be static and boring. Although the Parliament building is symmetrical, the surround is not. The trees and cloud formation on either side break up the perfect symmetry of the building, increasing the interest. The partial circular base in the foreground provides a strong perspective that leads directly to the Parliament building. It is a well-composed photograph.

The ground we walk on, the plants and creatures, the clouds above constantly dissolving into new formations—each gift of nature possessing its own radiant energy, bound together by cosmic harmony. Ruth Bernhard

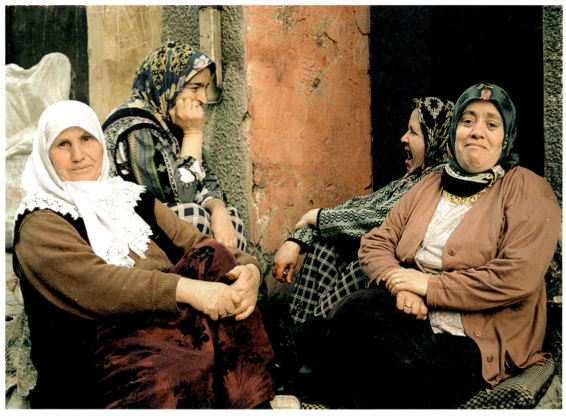

Turkey *Fatima NeJame*

This photograph is somewhat symmetrical, with two women on one side and two on the other. It is well balanced and provides much variety with the way the women are dressed and position themselves. They wear different colorful dresses, have different expressions, and hand positions. Two in the front and on opposite sides look at the viewer, while the two behind them are engaging each other. The background, in its wide vertical stripes of muted colors, echoes some of the color the four women are wearing. It is an interesting background in itself and helps to draw attention to the women without drawing attention to itself.

New images surround us everywhere. Lisette Model

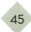

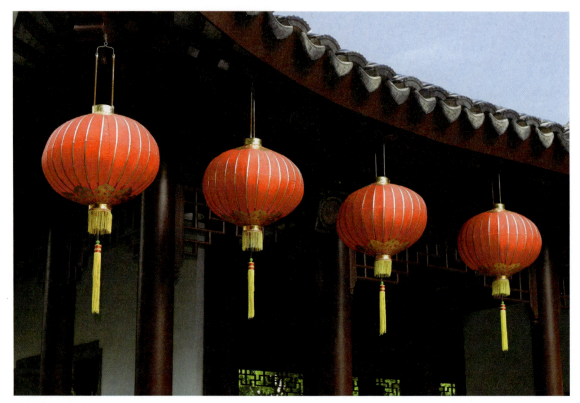

Red Lanterns

Repetition: Repeated visual elements in this photograph are linear and predictable. As with music, one can imagine the red lanterns, which decrease in size, as a constant drumbeat whose sound gradually diminishes. As the sound diminishes, so does the size of the lanterns. And as the level of sound continues to decrease, so does the size of the red lanterns, which can be imagined as continuing beyond the frame. The upper curve of the roofline repeats the curves of the lanterns. As we see here, objects that are similar and close together can be seen as a unit, as a repetitive pattern having their own beat. They can also be seen individually, as they all vary in size.

I found I could say things with color and shapes that I couldn't say any other way. Georgia O'Keeffe

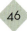

46

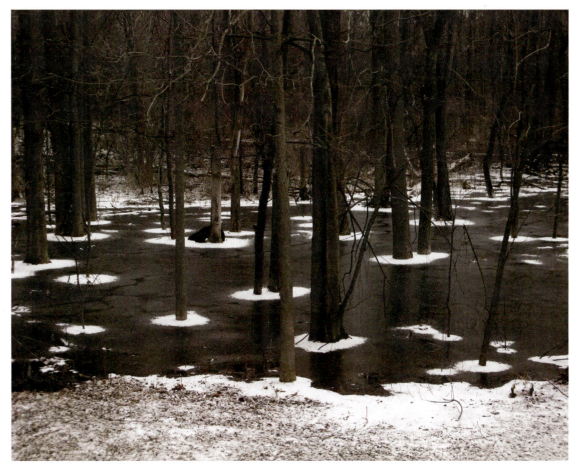

Floating White Rings *Irving Pobboravsky*

Unlike the predictable linear pattern of red lanterns, we see here a varied repetition of visual elements that create a more interesting pattern. This photograph was taken in early spring, just as the snow was beginning to melt. Narrow white rings cling to each tree trunk and resemble halos. The repetitive halos, which vary in their positions, do not have a constant beat but are more like a syncopated rhythm.

I didn't want to tell the tree or weed what it was. I wanted it to tell me something and through me express its meaning in nature. **Wynn Bullock**

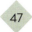

EXERCISES

Exercises are arranged in two sections. The first section involves looking at relevant photographs; not just looking but looking and studying, looking and seeing. The more you look, the more you will see, and the more you will learn and develop a discriminating eye.

The second section involves creating photographs that exhibit some of the geometrics of good composition.

Looking

1. An old Chinese proverb says "By reviewing the old we learn the new." We begin by looking at an Albumen photograph taken in Ceylon (Sri Lanka) by William Henry Jackson in 1894. Study this photograph and search out how geometry plays an important role in its composition. Look at other Jackson photographs in books and on the Internet and study his compositional style.

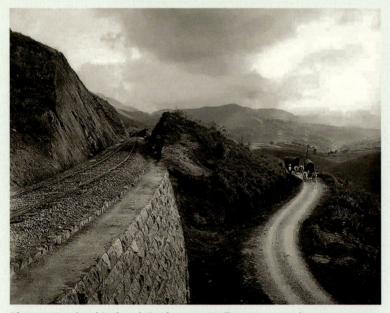

Photo 1. Road and Railroad, Ceylon 1894. William Henry Jackson.

2. This snapshot of Cole Weston and Richard Zakia was taken in 1983 during a workshop session at the Palm Beach Photographic Centre in Florida. Look over some of your earlier photographs for similar compositional features.

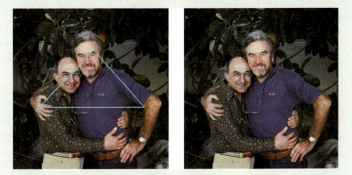

Photo 2. Friends. Thomas L. McCartney.

3. Refer to the painting "Washington Crossing the *Delaware*." Speculate as to why the painter chose to have the boat moving from right to left instead of left to right. Dr. Rudolf Arnheim, in his book "Art and Visual Perception," wrote that in the Western world, movement from left to right in an image is preferred—the way the eyes move when reading.

Photographing

Painters learned their skills by painting other painters' work. You may want to select a photograph that interests you and has good composition and try to imitate it.

1. Take a photograph of some friends or family and arrange them in such a way as to form a triangle.
2. Take two photographs of the same subject, one following the rule of thirds and the other not.
3. Photograph subjects having interesting lines, shapes, patterns, and curves such as S-curves, C-curves, and the like.

Figure Ground

Albert Paley Sentinel *David Page*

Figure-Ground Competition *Irving Pobboravsky*

Selection: The first step in seeing is selection—separating a figure (the subject) from the background (ground). Did you first see the white pedestals as figures? If you did, then the dark area served as the ground. But you could also have seen the dark area, which has a similar shape, as the figure. When you do, then the white pedestals become the ground. Figure and ground can change as your attention changes but cannot be seen at the same time. Some writers use the term positive space to describe figure and negative space to describe ground.

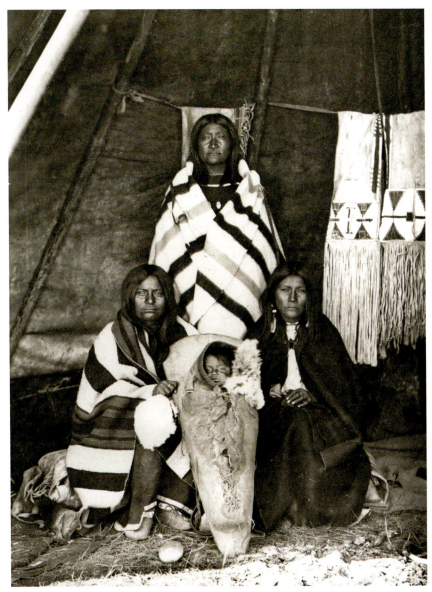

American Indian Women *William Henry Jackson*

Planned: Notice how Jackson positioned one of the hanging white throws behind the standing woman so that her head and dark hair do not blend into the dark background of the tent. This provides a good separation of figure and ground. He also arranged the group in such a way that the three women form a strong triangular shape with the baby, in a triangular wrap, in the center.

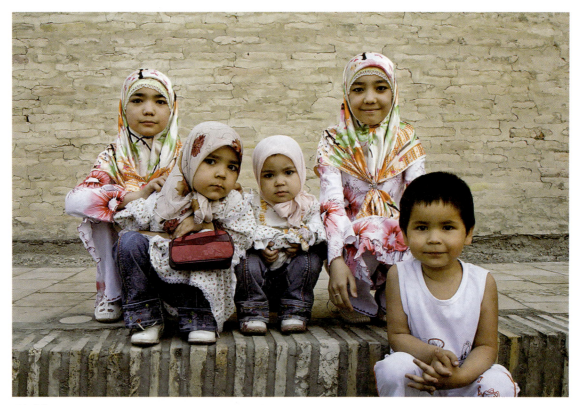

Children *Fatima NeJame*

Having these lovely Uzbekistan children positioned in front of an uncluttered background eliminates any distraction. Attention is on the lovely children as they look innocently at the photographer and at us as we view the photograph. The four girls all wear traditional head coverings, and one holds a small purse. The two girls sitting have a somewhat puzzled look. The higher girl on the right smiles and the one at the left simply looks at the camera. The arrangement of the children, with the boy in the front and the four girls staggered behind him in a flat U-shape, works well.

The test of the morality of a society is what it does for its children. Dietrich Bonnhoeffer

54

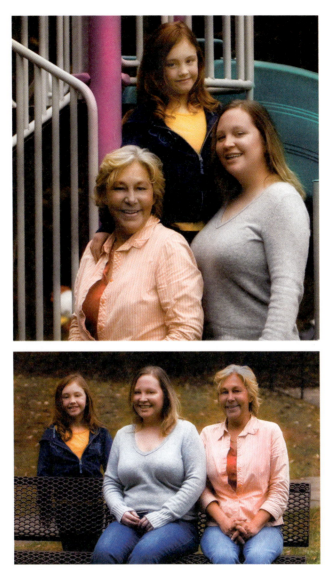

Mother and Daughters

Every photograph has a background. The background in the lower photo does not add much to the composition; neither does the way the two women and girl are arranged, all the same height, with their bodies perpendicular to the camera. In the upper photo, however, the colorful background, the bodies of the two women at a slight angle and the position of the three to form a triangle gives vibrancy to the photo.

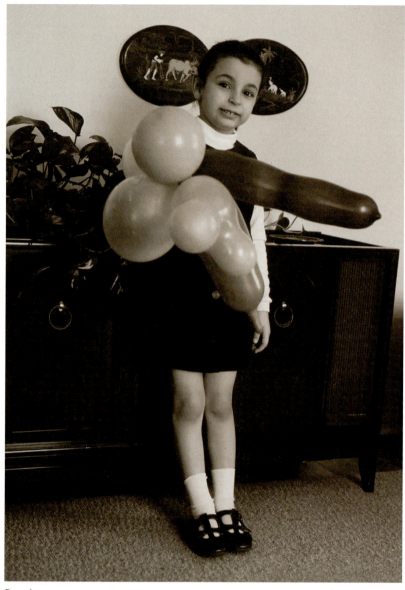

Renée *Richard D. Zakia*

There are times when you may want figure and ground to come together and join as one, as we see in the playful photograph of Renée holding her cluster of balloons. The position and proximity of her head in relation to the two oval pictures on the wall are easily seen as related.

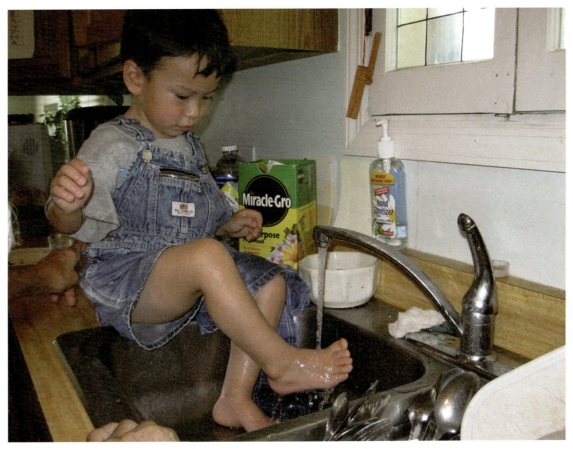

Michael James *Rita Bellingham*

Unplanned: Every photograph has a background, which can work with or against the intended subject. The background can be very carefully planed and set up or just be there and used without much thought. Here we see a young boy intently look at the running water on his feet. Not an unusual photograph until one notices that box of "Miracle-Gro" in the background and makes a humorous connection. This photograph is proof that great-grandmothers with a digital camera can take some interesting and unexpected photographs.

> I have found that the best way to give advice to your children is to find out what they want and then advise them to do it. Harry S Truman

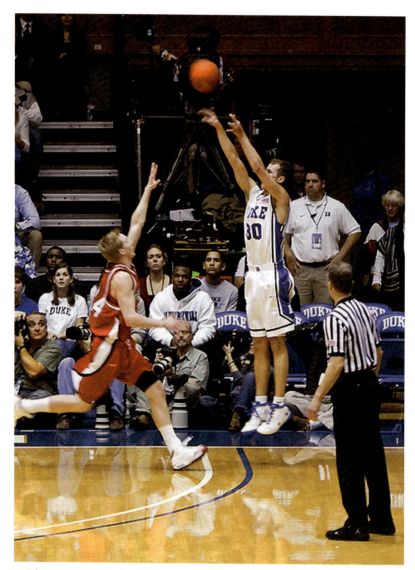

A Three-Point Basket *David A. Page*

Photographing sporting events that have fast action requires a quick response, as one has only an instant to capture the peak action. This photograph not only captures the moment but also the composition of a skewed triangle, anchored by the basketball at the apex. Notice that just behind the ball is a camera on a tripod, which forms a triangle that complements the player's triangle. Figure and ground connect.

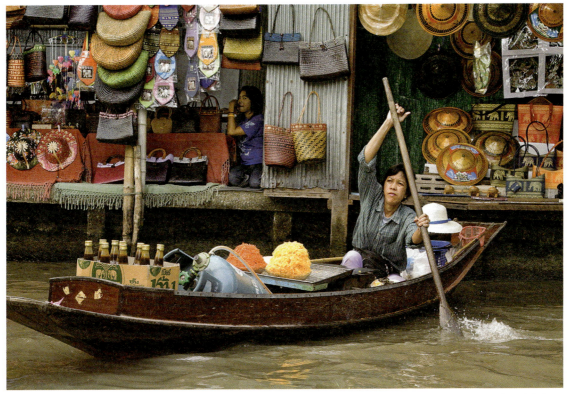

Bangkok *Fatima NeJame*

Sometimes a cluttered background is helpful by providing a context for the main subject, the woman in the boat, as she paddles away with the purchases she has just made. The rich background provides a colorful, varied, and interesting surround. It is important, however, that the main subject be dominant over the important but secondary surround. Figure and ground support each other very well. If the background were plain, the photograph of the woman in the boat could be ambiguous and subject to mistaken interpretation. One is invited to spend time with the photograph and learn something about how people in this part of the world live.

No race can prosper till it learns that there is as much dignity in tilling a field as in writing a poem. **Booker T. Washington**

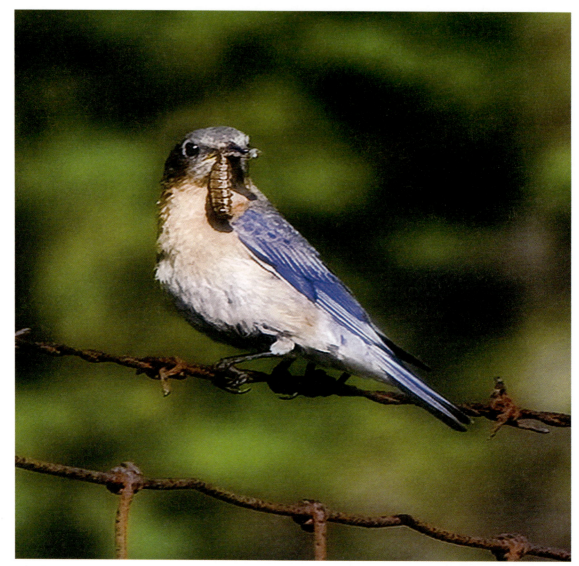

Bluebird *David A. Page*

A long telephoto lens was used to capture this female bluebird. Because telephoto lenses have a shallow depth of field, the background is out of focus, giving full attention to the bird.

The moment a little boy is concerned with which is a jay and which is a bluebird, he can no longer see the birds or hear them sing. Eric Berne

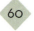

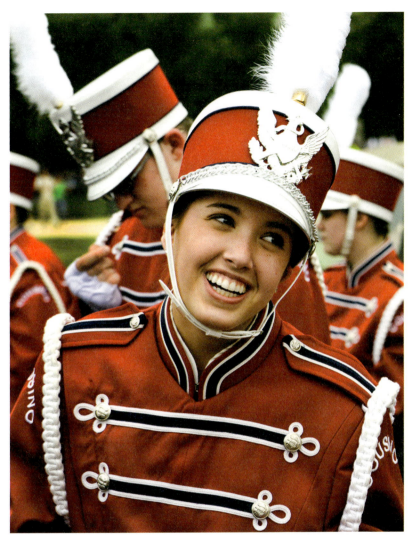

Before the Parade *Barry Myers*

Figure and Ground Compete: When photographing a person in a crowd, one does not have the luxury of selecting a background. Most important is the capture of the intended subject at the moment of greatest interest, as we see here. The figure in the foreground is captivating, with her joyful smile and slightly tilted head. Unfortunately, other members of the band in the background have the same dress and color, which can draw the eye away from the main subject. Fortunately, the depth of field is shallow, causing them to be out of focus and to therefore draw less attention.

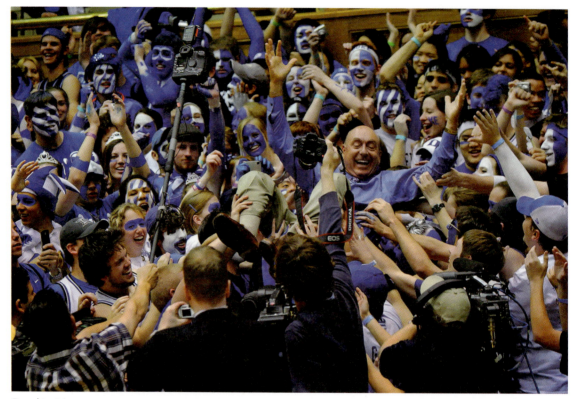

Dookie V *David A. Page*

In this full-frame image, famous basketball commentator Dick Vitale is given a ride in the student section of Duke's Cameron Indoor Stadium before a big game. The field of blue painted students almost hides a perpetually smiling Vitale as cameras, video cameras, and cell phones record the action from a low vantage point. The viewer is first presented with a mild visual problem: finding the subject, who is the focal point, amongst the clutter of blue and white bodies. The students then become secondary to the iconic sports figure, as he is found in this "where's Waldo"–style image. After sharing Vitale's joy, the details of the crowd attract attention; the viewer sees the many individual reactions to the focal point and the students display their individual personalities in dress and face paintings, yet remain secondary to the main subject. The action determines this composition. Careful consideration, and including the cameramen and excluding the adults in the stand above the rail, was an on-the-spot compositional decision, which in the first case supported the action and in the second would have been a distraction if included in the shot.

Untitled *U.S. Marine Corp*

Camouflage: As you look at this photograph, you are probably puzzled as to what is hidden in that field of tall growth. Your eye will scan back and forth, up and down, trying to pick up a clue, trying to separate figure from ground. As you have no idea what you are looking for, the task is difficult. Knowing that it is a camouflaged photograph is not of much help, for it reveals nothing except that something is hidden. If the photograph were captioned "Sniper," it would help direct your attention. And if you noticed the opening of a gun barrel at the lower left of the photograph, it would assist you in identifying a well-camouflaged sniper.

Harlequin, cubism and military camouflage had joined hands. The point they had in common was the disruption of their exterior form in a desire to change their too easily recognized identity. Roland Penrose

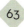

Ferns *David Page*

This is another camouflaged photograph in which something blends with the background. The title "Ferns" is a decoy calling attention to them and not to what is hiding. The short blue column to the upper left and the partial tree trunk to the right are easily seen. Not knowing what to look for increases the difficulty of seeing what is hiding.

Had the caption of the photograph been "Lizard in Hiding," you would have instantly searched for him. Finding him, however, will still take time, for he is well hidden and belongs in such an environment—nature's way of protection. To help you in your search: he's in the lower-left quadrant of the photo and his face and tail are visible. When something is similar in color, shape, and size, as is the small lizard, it is quite difficult to separate it from ground and see it as figure.

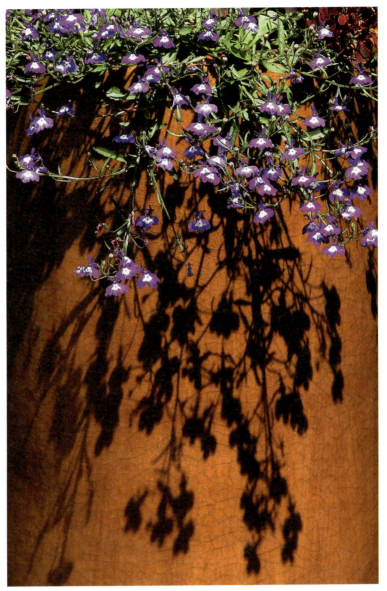

Flowers and Shadows *Vicki H. Wilson*

Strong cast shadows in a photograph such as this can be captivating, as they compete with the flowers for attention. One can chose to see flowers or shadows as figure. Both tend to draw attention. The viewer is invited to flip back and forth between one.

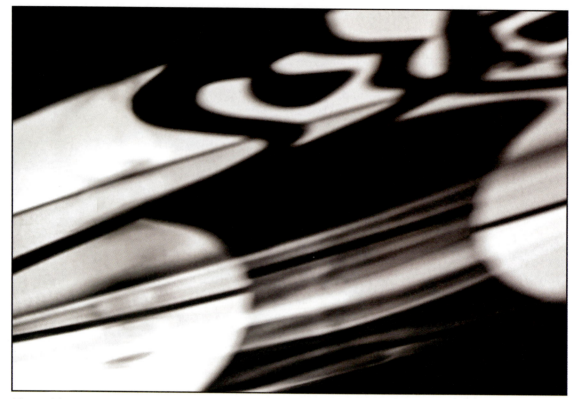

Notan No. 3 *Vicki H. Wilson*

Notan: The importance of negative space (ground) being seen as having shape and being harmonious with shapes in positive space (figure) is an example of *Notan*. In a black-and-white photograph, as we see here, the negative space is sufficiently enclosed that it can be seen as having shape. Neither figure or ground are dominant; they balance each other.

Notan No. 3 is a cast reflection and shadow on the wall from sunlight passing through a crystal vase (lower portion of the image) sitting on a glass-top table and carved table base (top portion of the image). The original exposure is cropped slightly and then converted to black and white. The contrast was increased to the maximum to emphasize an almost even distribution of negative and positive spaces. Some famous corporate logos are examples of Notan; another example is the familiar Chinese yin-yang symbol of Taoism.

Related masses of dark and light [Notan] can convey an impression of beauty entirely independent of meaning. Arthur Wesley Dow

66

EXERCISES

Looking

Paul Strand's 1916 photograph *Abstractions, Porch Shadows, Twin Lakes, Connecticut* is an interesting pattern of linear and curved shapes. It is also a study in the changing figure–ground and black-and-white rectangular shapes. His earlier photograph *The White Fence, Port Kent, New York, 1915* is another example of figure–ground at work. One first sees the white contoured boards as figure, but can shift attention to the black spaces in between, which have similar contours to its surroundings. The effect is like the figure–ground photograph by Irving Pobboravsky seen at the beginning of this section.

Photo 1. "The White Fence, Port Kent, New York, 1915." Paul Strand.

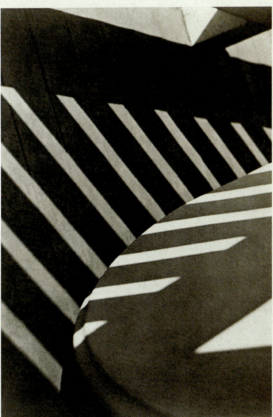

Photo 1b. "Abstractions, Porch Shadows, Connecticut, 1916." Paul Strand.

Look at this familiar FedEx logo and notice how the white negative space in the red area becomes an arrow when you attend to it as figure. In the blue area notice the white area in the letter d and the letter e. If you form a closure on the white area in the letter e, it will echo the white shape in the letter d. Much thought goes into designs, in which figure ground plays an important role.

Google Aaron Siskind and study some of his abstract expressionist photographs titled "Chicago". Observe the harmonious relationship between figure and ground between the black shapes and the white shapes, a wonderful example of Notan (see page 66).

Photographing

1. Create a photograph that cleverly plays figure against ground, photos that can challenge our way of seeing. You may want to begin by photographing the work of designers and how they arrange figure (positive space) and ground (negative space) to create a well-balanced design. Photograph some hubcaps on cars that interest you and study the relationship in how figure and ground work together and do not compete.

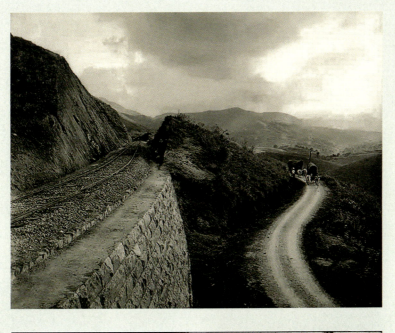

2. Practice patience. Find a subject that interest you and use it as a background for someone or something to enter the scene, thereby increasing the interest. Catching the blue motorcycle and rider as he passed was the result of waiting and a bit of luck.

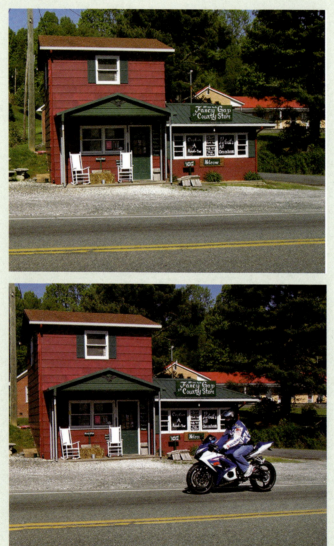

Photo 2. Colorful Country Store Richard D. Zakia.

While there is perhaps a province in which the photograph can tell us nothing more than what we see with our own eyes, there is another in which it proves to us how little our eyes permit us to see. Dorothea Lange

Depth

Mount McKinley *William Stanko*

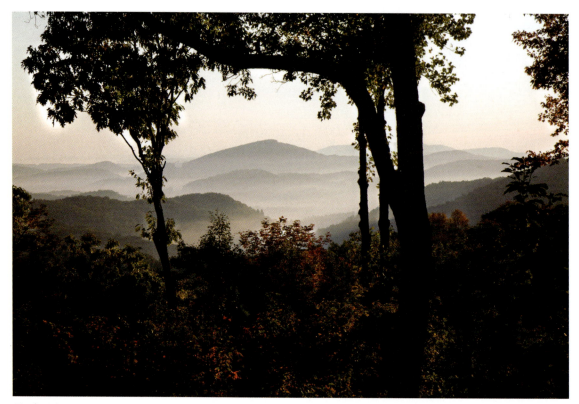

Early Morning *Vicki H. Wilson*

Multiple Planes: The perception of depth in this landscape is due to several depth clues. The two arching dark trees and the dark shrubs establish a strong foreground. As we look beyond and into the valley, we see the lighter multiple planes (mountain ranges) in the midground and farground, which provide a sense of greater depth due to overlap—one plane is seen in front of another. The last darker row of distant mountains, framed by the two trees, establish yet another distant plane in front of a pastel sky. The dark trees and foliage in the foreground contrast strongly with the lighter background.

For me, the creation of a photograph is experienced as a heightened emotional response, most akin to poetry and music, each image the culmination of a compelling impulse I cannot deny. **Ruth Bernhard**

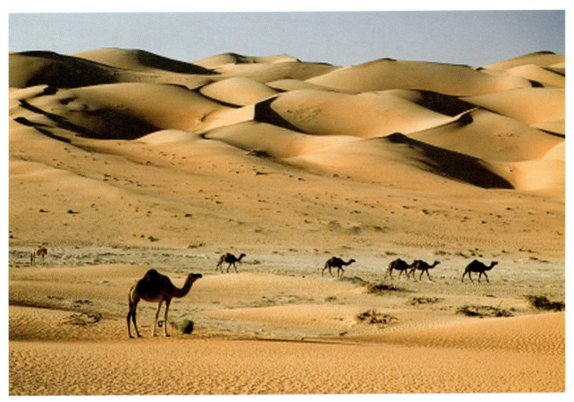

Dromedaries

Several clues for the perception of depth are in this photo. They include diminishing object size, multiple planes, and overlap. The size relationship between the large dromedary camel and the smaller camels in the midground suggests distance. Three planes are evident, with the large camel in the foreground, the smaller camels in the middle ground, and the overlapping multiple sand mounds high in the background. All provide an additional feeling of depth. The large camel in the left foreground is critical to the overall sense of depth. Without this dominant camel, depth perception would be diminished. Covering the camel with a finger will show this.

Only the desert has a fascination—to ride alone—in the sun, in the forever unpossessed country—away from man. This is the great temptation. D. H. Lawrence

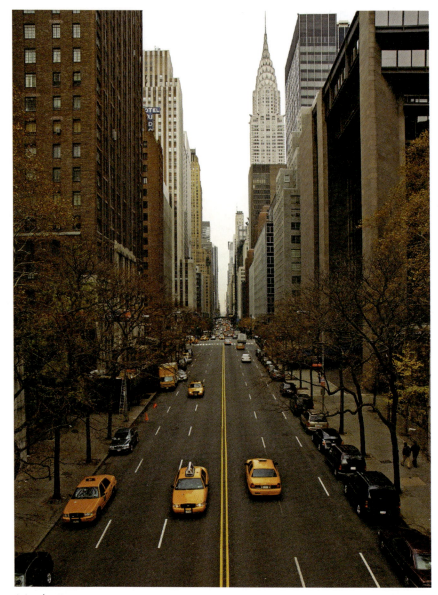

Manhattan *David Spindel*

Linear Perspective: This is an elevated view of 42nd street in New York City. Three yellow taxicabs side by side in the foreground provide a reference point for the diminishing size of the buildings. Adding to the sense of depth are the narrowing road, yellow lines, cars, and trees. The famous Chrysler building, a city landmark, stands tall and proud in the distance.

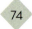

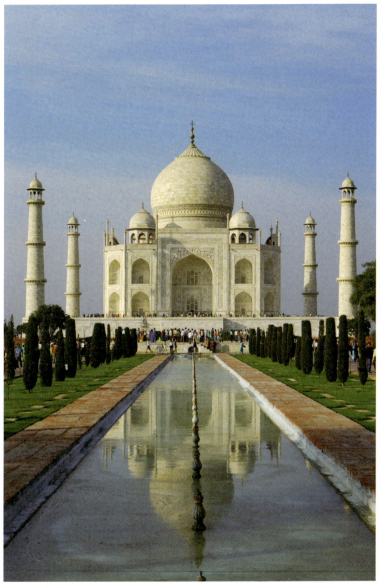

Taj Mahal

This photograph of the Taj Mahal is an excellent example of how converging lines provide a feeling of depth. The shrinking size of the tall narrow towers and the green trees on either side of the water add to the depth perception. One can also get a sense of the size of this beautiful structure by the smallness of the visitors in front of it. Built in 1653 as a mausoleum in memory of the emperor at that time, it is said to be the finest example of Mughal architecture.

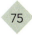

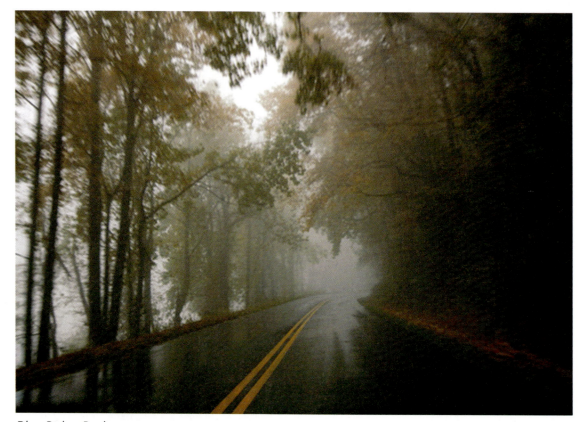

Blue Ridge Parkway *Vicki H. Wilson*

Aerial Perspective: Photographs are two-dimensional, having only length and width, whereas the world provides an added dimension of depth. There are learned clues in a photograph, however, that suggest depth. One such is aerial perspective, as we see here in this misty haze in the distance. The converging yellow lines add to the vicarious experience of depth. The photograph was taken from a moving car—hence the blurring of the trees in the foreground. The road disappears into oblivion, creating a greater sense of depth than would be seen on a clear day. Reflections on the wet pavement also increases the sense of depth, adding interest to the foreground. Fog and mist can enhance an otherwise mundane photograph by creating a sense of mystery and intrigue, forcing the viewer to question what lies ahead.

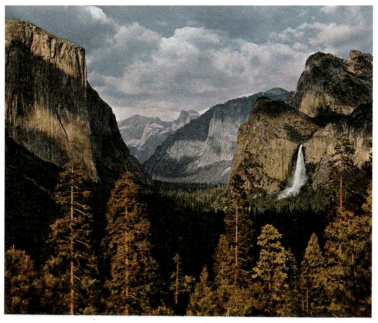

Yosemite National Park—Cloud shadows are used to
separate planes and give added depth to the picture

Ansel Adams' America...in Kodak Color

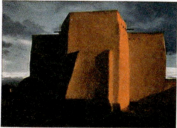

Ranchos de Taos Church in sunset lighting

ANSEL ADAMS lives in Yosemite,
conducts a school of photography
in San Francisco, and makes mag-
nificent pictures without end. To
his mastery of photography he
adds a deep, instinctive under-
standing of the outdoor world—
hence his wonderful success in
"interpreting the natural scene."

Color Perspective: The feeling of grandeur and distance, in this photograph taken in Yosemite National Park, begins with warm colors in the foreground advancing towards the viewer while the cool colors in the background recede. The overlapping mountain ranges increase the sense of distance and depth. The fine print in upper caption reads "Cloud shadows are used to separate planes and give added depth to the picture."

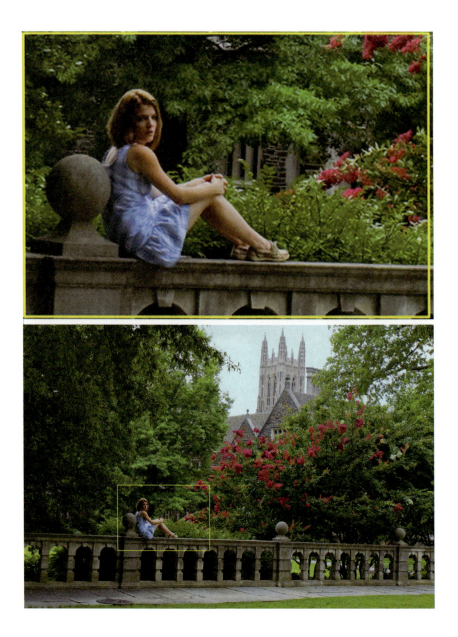

Camera Distance: There is a common misconception that the focal length of a lens controls perspective. This is not so. Choosing a focal length controls only the angle of view. (The shorter the focal length, the greater the angle of view.) The relative distance between the camera and subject controls perspective (the relative sizes of objects at different distances in a photo).

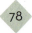

For a fixed camera-to-subject distance, perspective will not change. In the examples presented here, you can see that by enlarging the yellow section in the photo taken with a normal lens, the enlarged photo has the same perspective as the one taken with a long lens (upper photo). Although the perspective remains the same, the yellow framed photograph on the top left suffers from low resolution because of the extreme magnification of the section of the photograph below it. The correct course of action is to first select the camera position which provides the most suitable perspective and then choose a focal length lens whose angle of view will include your area of interest. (All Photographs by David A. Page)

The field of view is determined by the focal length of the lens. Short focal length lenses provide a wide angle of view whereas long focal length lenses provide a narrow angle of view. Vicki Hutto

Joan, Palm Beach Florida *Richard D. Zakia*

Texture Gradient: Another important depth clue is the *texture gradient*, which refers to the fact that as objects get further and further away, the interval between them becomes progressively smaller. This can be readily seen in the vertical poles, where the interval between each pole becomes smaller and smaller, to a point where the poles are almost touching. The experience of depth would exist even if all the poles were the same height. One can also notice that the boards on the dock are diminishing in width as they move further and further away.

It is striking to note how few straight lines, parallel or not, appear in a landscape not yet touched by human hands. **Maurits Escher**

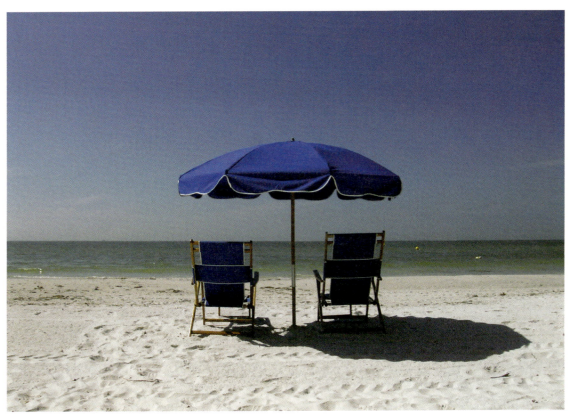

Blue Beach Chairs *Gordon Brown*

Shared Contours: At first look, this photograph appears to be nothing more than two empty blue beach chairs under a blue umbrella—lovely blue sky, calm bluish-green water, and warm sunlit sand. The photo is well composed and the horizon line is near the center, allowing equal space for both beach and sky. However, if you look closer, you will notice that the chair on the right sits solidly on the beach due to the depth cue of overlap—it overlaps the water and sky and therefore must be in front of them. The chair on the left, however, is not sure where it is, for the top part, sharing the same contour as the horizon line, positions itself at the horizon. The bottom part remains on the sand. Visually, the chair is in two places at the same time—a physical impossibility, yet a visual reality. Shared contours collapse depth; overlap defines it.

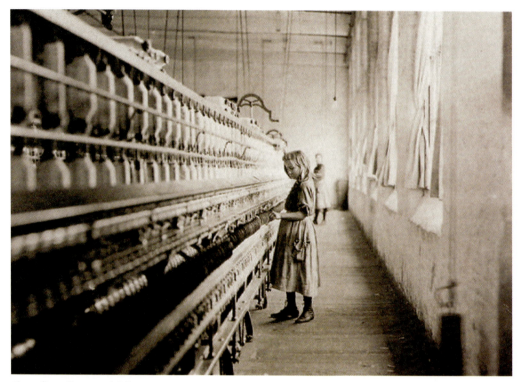

Carolina Cotton Mill, 1908 *Lewis W. Hines*

Depth of Field: If you look carefully at most photographs, you will notice that not everything is in sharp focus. The amount that is sharp compared to that less sharp is referred to as "depth of field"— the range of sharpness in a photograph. In this photograph by Lewis Hines, we can see that much of what is in around the young girl working at the loom is sharp, but much that is in front of and behind her is not sharp. We can say, therefore, that the depth of field for this photograph is shallow. There are a number of reasons for this. Because of limited lighting in the building, Hines probably had to use a lens with a large opening to let as much light into the camera as possible and a shutter speed fast enough to stop any movement by the young girl. Things that can improve depth of field in a photograph are: small apertures (such as $f/22$), short focal length lenses (50 mm or less), and greater camera distance from the subject. There are times, however, when you want a shallow depth of field, such as photographing a flower and having the background unsharp so as not to compete with the flower.

In my early days of my child-labor activities I was an investigator with a camera attachment ... but the emphasis became reversed until the camera stole the whole show. **Lewis W. Hines**

Lady in Red *David A. Page*

In both photographs, the lady in red is in sharp focus, and in the top photo the background is also in sharp focus. However, in the lower photograph the background is not in focus and appears blurred. The upper photograph is said to have a greater depth of field. Factors that increase depth of field are: small apertures (large f-stop numbers), short focal length lenses, and greater distances between the subject and camera. The top photo was taken at *f*/32 and the bottom one at *f*/5.6.

EXERCISES

Looking

Painters learn from other painters. Photographers can do likewise. Helen Levitt visited museums to study and learn composition. There is a richness of paintings in museums and galleries that one can learn from, and there is also the Internet, which is easy to navigate to find works of painters and photographers. There is no substitute for seeing original work, of course, but seeing reproductions can be very helpful in studying composition and lighting. If your interest is in landscape and you are not already familiar with the work of John Constable (1776–1837) or of Albert Bierstadt (1830–1902), introduce yourself. Constable was an English Romantic painter and Bierstadt was a German American painter and part of the Hudson River School.

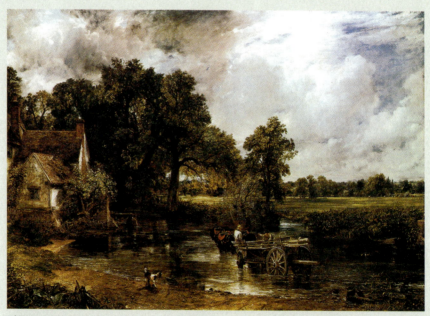

Photo 1. The Haywain, 1821 John Constable.

Photo 2. Among the Sierra Nevada Mountains, California (detail), 1868 Albert Bierstad.

Some of the early photographers that you may want to look at to study depth in a photograph include Gustav Le Gray (1820–1884), Francis Frith (1822–1898), and Charles Marville (1816–1879). Le Gray was one of the most important French photographers of the nineteenth century—a technical photographic innovator. Frith was an English photographer of the Middle East and many towns in the UK. Marville was another French photographer who specialized in architecture and landscapes.

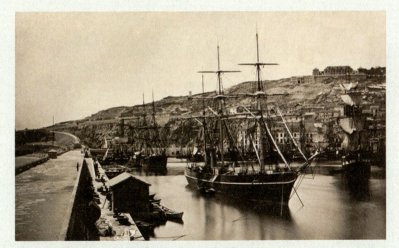

Photo 3. The Steamer Said, 1857 Gustav Le Gray.

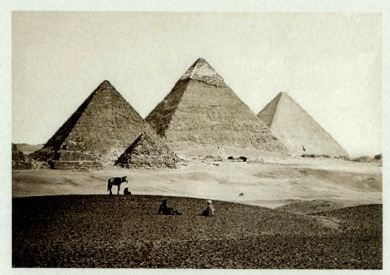

Photo 4. Die Pyramiden von Gizeh, 1858 Francis Frith.

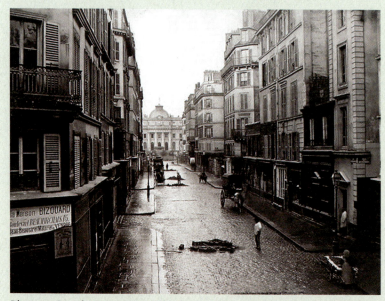

Photo 5. Rue de Constantine Charles Marville.

Photographing

1. Show that at a fixed distance a different focal length lens does not change the perspective of what you are photographing. Use the normal lens on your camera and then the zoom.
2. Perspective is controlled by the distance your camera is from the subject not the focal length of the lens. Photograph a subject at different distances using the same focal length lens.
3. Photograph a scene so that the contour of the object in the foreground coincides with the contour of an object in the background.

Framing the Scene

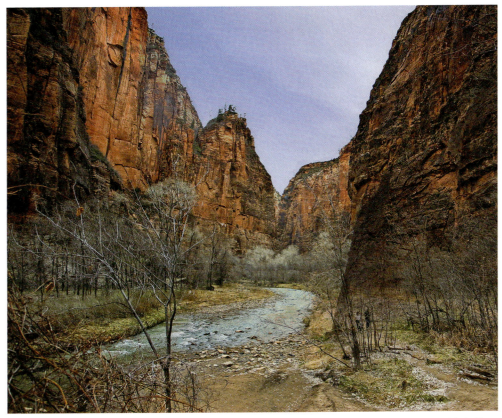

Zion National Park *David A. Page*

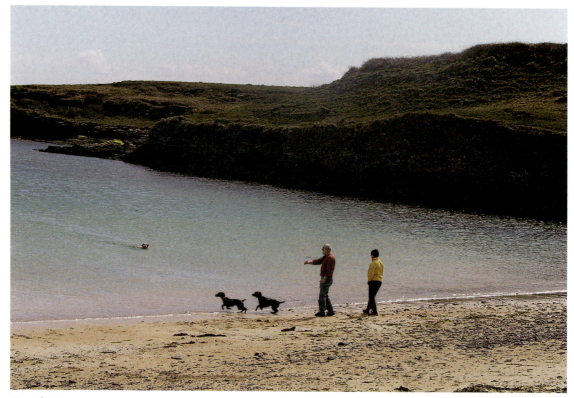

Family Outing *Richard D. Zakia*

Object in the Foreground: The edges of an image are called the *frame*, as can be seen on any camera's LCD screen, DSLR viewer screen, and, of course, the photograph. What one decides to select in a particular scene is called *framing*. In this photograph, the man and woman by the water's edge with their three dogs were selected and included in the picture frame as were parts of the landscape to the left and right of them. One dog is in the water swimming towards shore, while the other two are at attention on the shore with their tails pointing upward. The two dogs serve as a counterpoint to the couple. The foreground of the beach, middle ground of the water, and background of the hilly land provide a friendly setting. What lies outside the frame is assumed to be more beach, water, and hills.

Be attentive to what's before and beyond the focus plane. The framing is
the formality of it. William Eggleston

Rustic Homes *Denise Felice*

Framing: Objects in the foreground of a scene can serve as a framing device for objects further away, as we see here. The two large tree trunks act as curtains for the scene beyond: the three old rustic homes. Both trees and homes are probably of the same vintage. The sunlit grass in the midground contrast with the dark shadows under the trees and provide an added dimension of depth. There is a sense of nostalgia and mystery in the photograph, as one might wonder whether the homes are occupied, and if so, by whom.

The ground we walk on, the plants and creatures, the clouds above constantly dissolving into new formations—each gift of nature possessing its own radiant energy, bound together by cosmic harmony. Ruth Bernhard

91

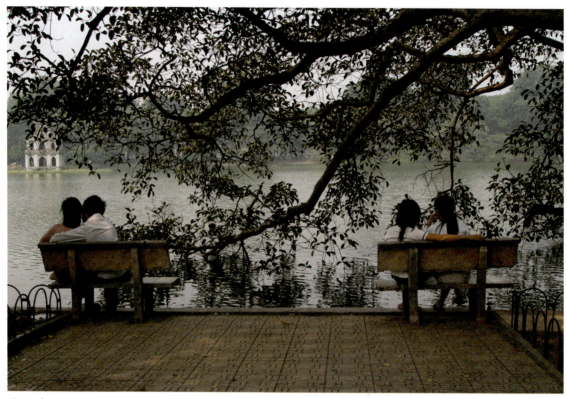

Couples *Fatima NeJame*

By using the two couples on benches as a frame and photographing them from behind, we are invited to vicariously enjoy the quiet, placid scenery in front of them—rippling water, a large hanging tree limb touching the water and a castle-like structure to the distant left. The photo is nicely framed and balanced with an attractive brick pattern in the foreground. The couple embracing on the left bench gives the photo a romantic feeling and reflects some of the unseen beauty in Vietnam.

The value of composition cannot be over estimated: upon it depends the harmony and the sentiment. Gertrude Kasebier

Malay Woman

Focal Point: Wherever the eye is directed or impelled to look in a photograph is called the *dominant point* or *focal point*. Here, the attractive Malay woman is the focal point—the center of interest. The exotic and famous Putrajaya Mosque in the background serves as a secondary point of interest and provides a setting for an informal portrait. (See chapter 9 for more on portraits.)

Nature and Man *Denise Felice*

Scale: The man is dwarfed alongside this majestic land formation, but he gives scale to the Ring of Kerry in Ireland. Cover the man with your finger and notice how the size of the formation is diminished.

Young Man

Vertical: Vertically framed photographs suggest strength, power, and height, as we see in this photograph of a well-dressed young man. He stands tall and confident with his arms folded and with warm eye contact. The plain background provides no environmental clue as to his role in society. He projects the image of a professional person, however.

If you want to succeed, double your failure rate. Tom Watson, IBM Pioneer

95

Tall Trees

A series of vertical forms, such as these majestic tree trunks, works well as either a vertical or horizontal. To accentuate the height of the trees, a vertical is preferred. To show the expanse of the trees and forest, a horizontal is best. In either case, it is critical that the trees be seen as vertical within the frame, because they will be compared with the vertical edge of the frame.

Perception is relative. Rashid Malik

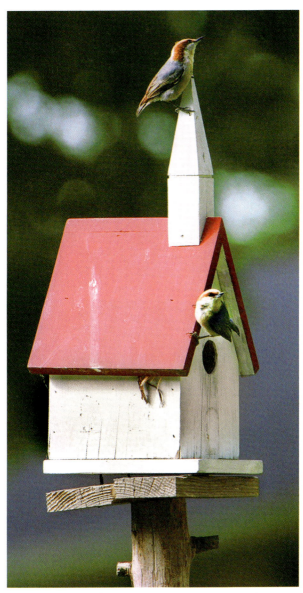

Standing Guard *David A. Page*

Photographs of a single vertical form are best seen in a vertical format, as in this birdhouse with a perched nesting pair of brown-headed nuthatches. The viewer's eye is drawn vertically by the birds and the red roof of the birdhouse.

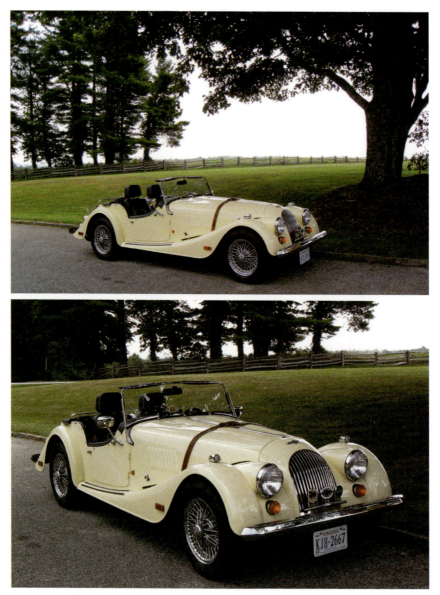

Morgan Classic *Richard D. Zakia*

Move in Close: The top photograph provides a broad country setting for the car, whereas the bottom photo places more emphasis on the car and less on the setting. Showing the car from a different vantage point and sharper angle provides a more dramatic look.

Scribe *Howard LeVant*

Move in Closer: In this photograph, we are provided with an up-close and intimate look at a spe-cially trained scribe (Sofer) preparing a new Torah.[1] So as not to disturb or distract him, natural light was used. A slightly wide-angle lens was used to draw the viewer into the frame. The camera was care-fully handheld and steadied. If a long focal length lens had been used, the intimacy would have been lost. In terms of composition, and in a personal note, the photographer wrote, "The image is comprised of two triangles, which divide the photograph evenly in half from upper left to lower right. I made the scribe the subject of the upper left triangle and the parchment being written on the lower right part. By allowing his arm to cross the centerline from the left the two triangular parts become one."

[1] The Torah is the Hebrew Scroll version of the Old Testament's Five Books of Moses.

Threesome *Richard D. Zakia*

Part for the Whole: Sometimes showing just part of a subject in a photograph is more interesting than showing the entire subject. It invites the viewer to enter in and complete the photograph as he or she wishes. In this photograph, we see the lower part of three people standing around, probably in a conversation. We can identify two men and a woman. That one of the men is dressed in his native Indian clothes adds interest, for this is no ordinary gathering. Is he a visiting dignitary? What is the occasion? The woman is conservatively dressed and stands between the two men. The questioning can continue, for there is no answer to the photograph other than the one you give it.

I often painted fragments of things because it seemed to make my statement as well as or better than the whole could. Georgia O'Keeffe

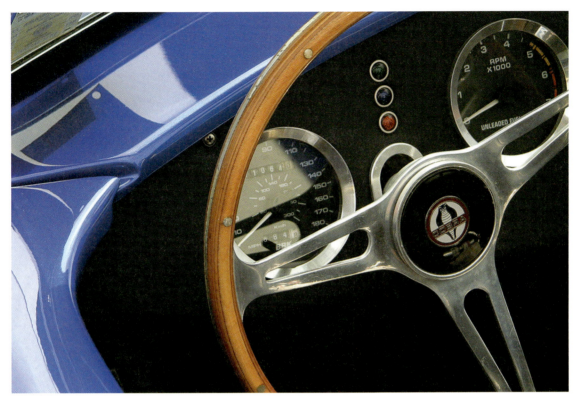

Ford Cobra *Vicki H. Wilson*

This close-up of a Ford Shelby Cobra was composed in camera to identify the sports car by its famous name and symbol on the steering column. Angles, curves, and vivid colors also make this car an ideal subject for composing, to a show a part of the car. Photographing only a portion of a subject draws attention to specific details and potentially allows viewer interpretation. However, if the photographer's intent is for the viewer to clearly identify the subject, the composition must include sufficient visual information for this purpose. One interested but not familiar with this car may want to go on the Internet for a look.

The camera doesn't make a bit of difference. All of them can record what you are seeing. But, you have to see. Ernst Haas

Kissing Madonna *David A. Page*

Fill the Frame: By coming in tight on the subject, the viewer's attention is directed to the loving face of the Madonna and child. The child's left arm embraces his mother and the mother's hand embraces her child. This tenth-century fresco was photographed in Cpadocia, Turkey.

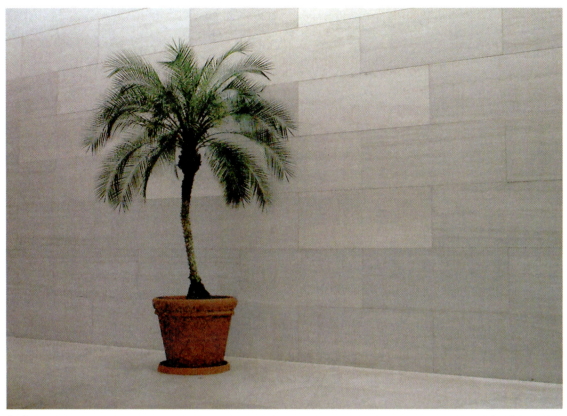

Palm *Richard D. Zakia*

Sometimes filling the frame can be effective by filling it not with the intended subject, but with the background, as we see here. By doing so, the palm tree is isolated, has a vast grayish background, and calls attention to itself. The contrasting green color of the branches and the red color of the pot complement each other, without interference, as might occur with a busy background. The soft lighting on the subject and wall add to the quietness of the photograph. It was taken at the national Museum of Art in Washington, DC.

Don't look for good pictures. Look at what's in front of you and photograph what most attracts you or repels you. David Vestal

Brothers *Vicki H. Wilson*

Frame Within a Frame: The edges of a photo determine the frame. Framing a photograph within a frame can be fun. When outdoors, look for natural settings such as clusters of trees or rock formations in which to place your subject. The young boys in this photo were having fun playing on the boulders.

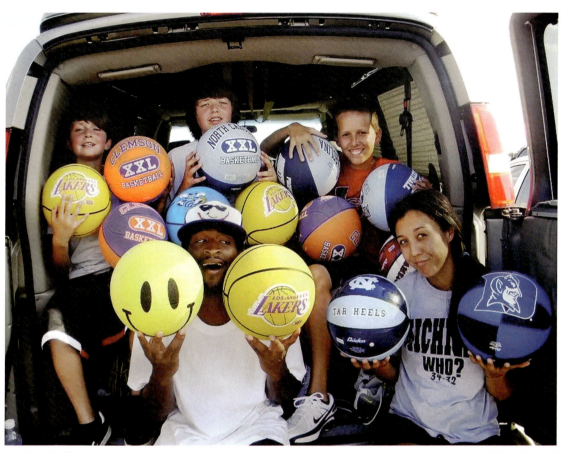

Basket Balls *Missy Harrill*

Placing a subject within a frame can provide a more interesting composition. Doorways, windows, arbors, gates, car windows, and the like work well. Here a fun-loving group of sport enthusiasts is framed within the open tailgate of a car, holding basketballs that they have proudly won. One can imagine the same group photographed alongside the car and not framed as being much less interesting. This photograph was taken with a cell phone. The quality of the image is rewarding.

Never boss people around. It's more important to click with people than to click the shutter. **Alfred Eisenstaedt**

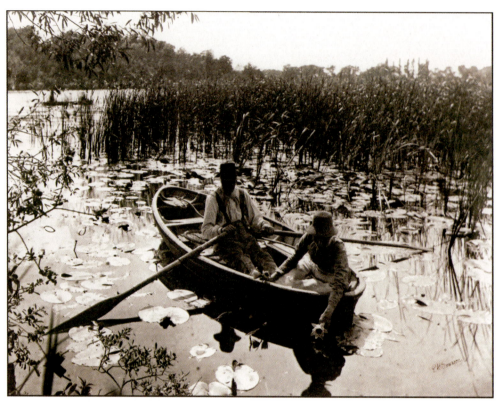

Gathering Water Lilies, 1886 *Peter Henry Emerson*

Position Within the Frame: Peter Henry Emerson's photograph is an early classic and is in the collection of many museums around the world. It is his signature piece. Emerson was a British physician who was born in Cuba; he took up photography when he was about 30 years old. He was one of the early pioneers in practicing photography as an art form and was passionate about nature. We see in this photograph a man and woman in a boat among floating lily pads and tall reeds in the background. The boat is at an angle and positioned in the center of the frame. Shadows of the boat, man, and woman are reflected in the water. The man handles the oars while the woman picks a water lily. The photograph can serve as a reminder not to be a slave to the rule of thirds or triangles. Be aware of compositional features, but when photographing, photograph with your heart and emotion.

I never ignored or lost sight of the fundamental and vital importance of composition. Peter H. Emerson

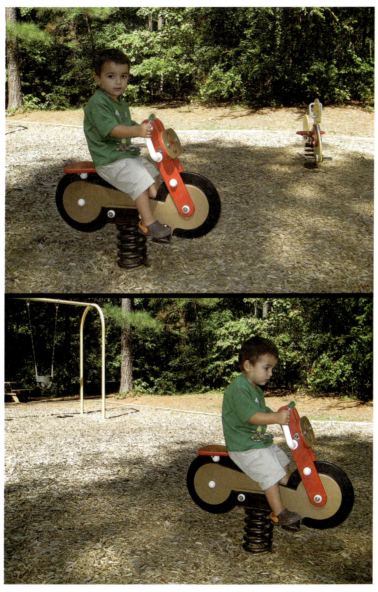

Joey *Richard D. Zakia*

In the top photograph, Joey—sitting on his stationery bike and looking at the viewer—has room to move within the frame, but not so in the bottom photograph.

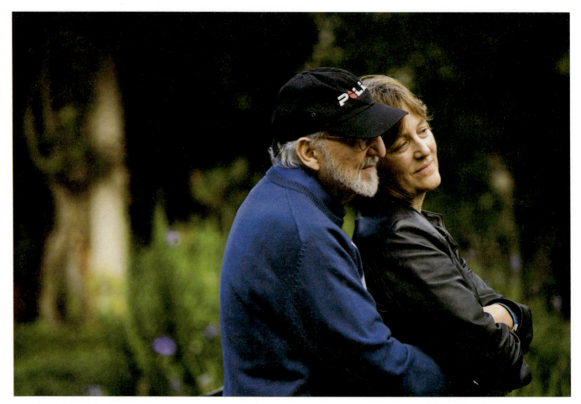

Carl and Heidi *Ken H. Huth/GEH*

Beyond the Frame: Carl Chiarenza and his wife Heidi visited the George Eastman House, where this portrait was taken. By having the background out of focus, attention is fixed on the couple as figure. The photographer positioned them at the upper-right intersection of the rule of thirds grid. They appear in a warm embrace, looking beyond the frame of the photograph. Had they been placed at the upper left of the grid, they would not. They would be looking within the frame. Placing them in the middle of the frame would result in a static and boring photograph.

Photography is a picture-making medium, like any other picture-making medium. It's a magnificent medium. Carl Chiarenza

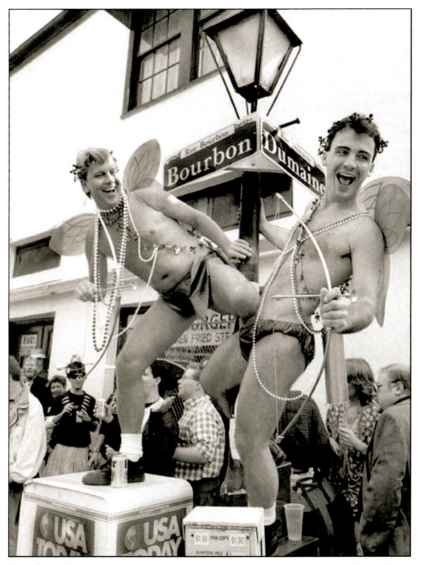

Bourbon Boys *Bruce Keyes*

Tilt: Mardi Gras is a time for fun and frolic, as we see here. The two men hang on to the street pole for balance, their bodies tilted. We, however, have a sense of imbalance as we view the photo—some of us more than others. This is because we depend upon things being vertical or horizontal for balance. To create tension in a photograph, tilt something.

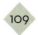

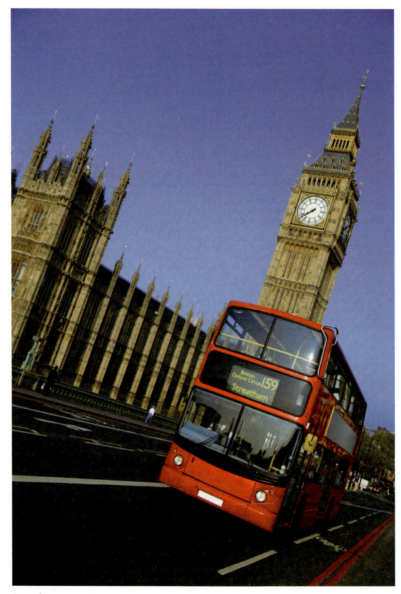

London

More Tilt: Some viewers will find this photograph unsettling to look at and may turn away from it. The tilt of the red bus, Parliament, and St. Stephen's Tower are extreme but add to the dynamic feeling of movement.

EXERCISES

Looking

This striking vertical photograph by French photographer Nadar (1820–1910) projects the apparent strength and confidence of a handsome young man, hand in pocket, head slightly tilted, looking askance at the viewer. It would still be powerful as a horizontal but would lose some of its impact.

Photo 1. Young Man. Nadar.

The Steerage, 1907 by Alfred Stieglitz is an iconic image and much has been written about it. Compositionally, the walkway at an angle provides a dynamic feeling and the tilted smokestack provides a feeling of imbalance. Both work together to activate the frame. Stieglitz saw *Steerage* as a study of line and balance, light and shade.

Photo 2. The Steerage, 1907. Alfred Stieglitz.

Imogen Cuningham's *Magnolia Blossom, 1925* is another icon that can be found in many publications. Her close-up photo captures the sensual beauty of the flower and demands our attention. It is a reminder that we do not spend enough time looking at flowers, as Georgia O'Keeffe has stated.

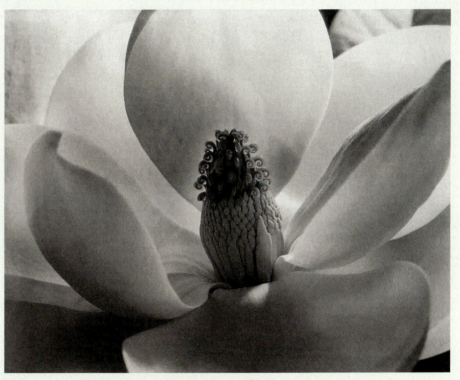

Photo 3. Magnolia Blossom, 1925. Imogen Cunningham.

Additional photographs by Nadar, Stieglitz, and Cunningham can be seen on the Internet. Look also for examples of framing by photographers such as Richard Avedon, Robert Frank, Freeman Patterson, Joel Meyerowitz, and John Pfahl.

Photographing

1. Move in close to capture the delicate beauty of flowers that you like and spend time studying their shapes and colors.
2. Take a straight photograph of a subject and then one with the camera tilted. Compare the two. Is one more engaging than the other? Play around with different degrees of tilt and subjects.
3. There are many different ways to frame a scene, including a frame within a frame, and, if you wish, within another frame. Have fun with one of your friends and frame him or her in an unusual way as David Page has done here.

Photo 4. Four Alarm Zakia. David Page.

Clarity

Descent *Richard D. Zakia*

Simplicity Puzzling
Complexity Illusion
Ambiguity Exercises

Praying Mantis *Peter Wach*

Simplicity: The simplicity of this photograph calls your full attention to the praying mantis positioned on a clear ball that nearly blends with the background. Arriving at such simplicity can be difficult. Considerable time, planning, and patience were needed to create this photo. The detail and clarity are amazing. It even looks as if the mantis were posing for a portrait. The structure of the insect's compound eyes creates the illusion of small black pupils. The position of the body and "hands" makes it appear as if he is praying.

Simplicity is the ultimate sophistication. Leonardo da Vinci

Parisian Dreams *J. Tomas Lopez*

Complexity: What appears to be a straightforward photograph of the inside of a subway car can, at second glance, be quite confusing. We see what appears to be a Paris street scene inside the car. Our first thought is that it is just a Photoshop manipulation. To the extreme left, we notice part of an open door and a blurred image of a person on the outside walking by. Evidently a slow shutter speed was used to adjust for the light level inside the car. In a discussion with the photographer, he revealed that there was no manipulation and that the Paris street scene had been painted in the car. The well-chosen caption *Parisian Dreams* adds to the photograph.

To perceive an image is to participate in a forming process; it is a creative act. Gyorgy Kepes

Puros Habano's *Richard D. Zakia*

Ambiguity: Have you ever come across a large painting of a landscape on the wall of a building and mistaken it for the landscape itself and not just a realistic painting? Looking at this wall might have brought about a similar experience. The patches of plaster on the side of this building along with the colorful billboard sign and blue sky provided the potential for an interesting photograph. In studying the wall, the question came up as to whether it was actually plastered that way or was painted to give the illusion of plastering. From a distance, it was difficult to tell, to be sure. It could be seen either way. (What is your guess?) It was only when the photographer walked up to the wall and took a close look and actually touched and moved his fingers across the wall that he could tell for certain that it was indeed a plastered wall and not just a painting on the wall.

The most difficult thing is what is thought to be the simplest, to really see the things that are before your eyes. Goethe

118

Score? *David A. Page*

Puzzling: A good sports photograph should normally include the ball or in this case a puck. Here, the fast-moving puck was captured just as it was nearing the net. Was it a goal or a miss? Did it enter the net for a score or not? Without some additional information, such as a caption, it is difficult to know for certain. It sure looks like it did from the vantage point in which the photograph was made. From a different vantage point, the shot would have looked different and perhaps less puzzling. Photographs that are puzzling challenge and engage the mind more than those that are not. (In this photograph, it may look as if the shot entered the net, but it did not.)

A good hockey player plays where the puck is. A great hockey player plays where the puck is going to be. Wayne Gretzky

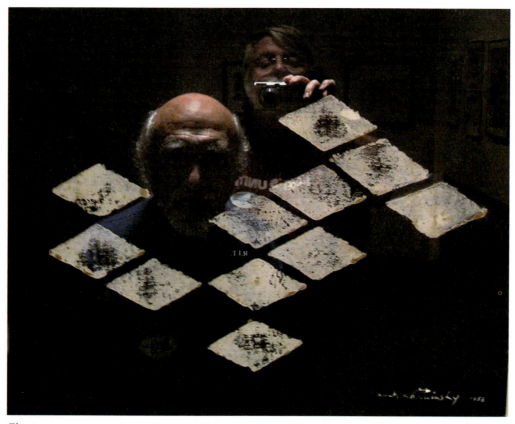

Floaters *David A. Page*

Photographs that are somewhat puzzling can hold a viewer's interest and provide a visual challenge. In this photograph, the reflection of two men is seen amongst what appears to be floating pages or prints. The person in the rear is taking the photograph as he looks at the LCD screen on his camera. The bald-headed person in the front is looking directly into the reflecting surface and therefore at the viewer. But what are those floaters in the picture doing? You probably noticed the paintings hanging at there left of the photo. What is being seen is the reflection of two men in a dark painting of floating "prints" against a dark background that acts as a mirror. In a sense, the photograph is layered.

No man has the right to dictate what other men should perceive, create, or produce, but all should be encouraged to reveal themselves, their perceptions and emotions, and to build confidence in the creative spirit. Ansel Adams

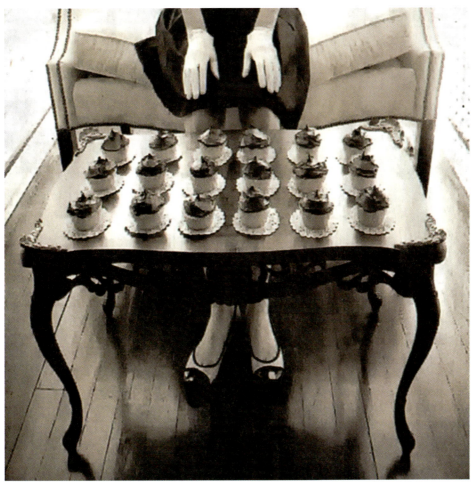

Southern Hospitality *Kitti Miller*

Illusion: A number of things are evident as one studies the image: the vantage point, the missing upper part of the woman, the white gloves against a black dress, the careful arrangement of desert cups on the table, the curvilinear legs of the table, and, of course, the centering of the subjects in the photo. In addition, the tabletop separates the knees of the seated woman from her feet poised on the floor. The legs appear to be longer than expected because of the interruption of the tabletop. A disrupted "line" will look longer than one not disrupted (called the *Oppel-Kundt illusion*).

What we see is not identical with what is imprinted upon
the eye. **Rudolf Arnheim**

Photographs chosen for a book cover should have great eye appeal and engage the viewer. This photograph by Edward Weston is, in a way, unusual in its apparent simplicity. We see an angular ceiling in which some of the areas appear to be projecting outward and some inward. The dark couple embracing in the lower left provide a sense of scale. A steady look at the "block" in which the couple occupy one small surface will cause the block to change its orientation inward and outward. In this Necker cube illusion, the perception of the block (cube) is not stable and "flip-flops" as you stare at it. Salvatore Dali and M.C. Escher have used this phenomenon in some of their paintings.

Those things, which are most real, are the illusions I create in my paintings. Delacroix

EXERCISES

Looking

1. The original painting by Adrian Coote (1683–1707) of a large white bird in the foreground is cluttered with birds in the background. The large white bird as a focal point (center of interest) is diminished. A later rendition of the same painting simplifies things, making the white bird more prominent.

Photo 1. Adrain Coote.

2. This photo is a bit puzzling as you attempt to figure out what it is. The focal point is a shadow of a child over markings on a large white paper. The shadows of the arms extend beyond the paper. The paper is curved, as its shadow suggests.

Photo 2. Liam's Shadow. Richard D. Zakia.

3. René Magritte (1898–1967), a Belgian surrealist artist, was a master of visual ambiguity. His paintings can be a springboard for visual ideas, as they have been for photographers like Duane Michals and Jerry Uelsmann. Be inspired. Look at some of Magritte's paintings.

4. To see some extremely realistic paintings that create an optical illusion in which a two-dimensional painting looks three-dimensional, go to Google or Wikipedia and type in "trompe l'oeil" (which means "fooling the eye").

Photographing

1. Look over some of your photographs and see if there is one in which you can call more attention to the center of interest by muting the background.

2. Create a photograph that is ambiguous or puzzling. Show it to a few friends and ask them to comment on what they see.

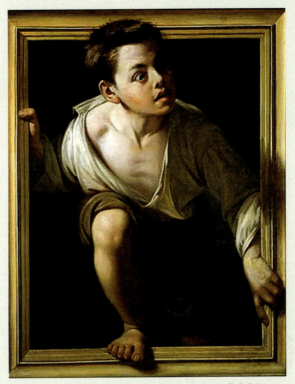

Photo 3. Escaping Criticism, 1874. Pere Borrell del Caso.

Movement

U-NU-LE (The Wind). *Stan Crocker*

Stop Motion Implied Movement
Panning Direction of Movement
Not Panning Exercises
Blur

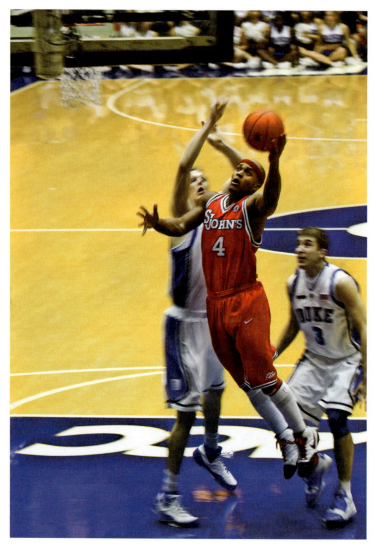

Power Move *David A. Page*

Stop Motion: Even though the camera's shutter speed was fast enough to stop the movement of the St. Johns basketball player, the fact that he is in midair conveys movement. The body angle and goal are strong clues as to the direction of that movement. The blur of the Duke defender's hand not only confirms action, but also raises the question "Was the ball swatted away or was it slam-dunked?" Either way, it was great college basketball and the viewer can answer the question in his or her own mind according to their allegiance. In either case, something spectacular is about to happen.

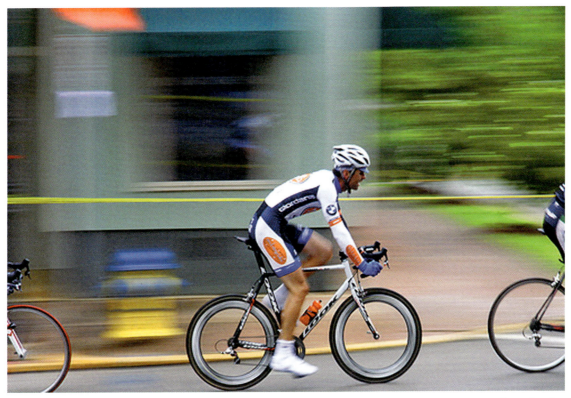

Bicycle Race *Stan Crocker*

Panning: The camera is focused on the bike rider, who is the center of interest. Carefully swinging the camera and following his movement produces a sharp rendition of the subject. This is, in a sense, because the camera is panned with the movement of the rider. The camera and the rider are moving together, but the background is not. The blurred background provides a double advantage. It calls attention to the rider and not itself and the colorful blur suggests a fast movement. An added feature is that one bike is going out of the frame and another is entering with the main bike and rider in the center of the frame. This provides an unexpected symmetry and adds to the action.

Your eye is the first camera. The camera is just an accessory between you and the subject. **Patrick Demarchelier**

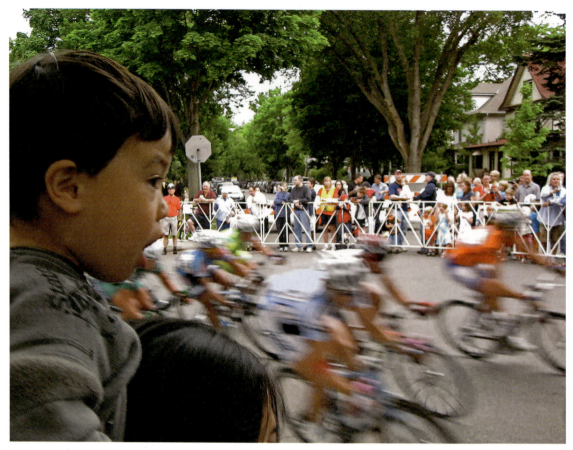

Interested Spectator *Michael Hutto*

Not Panning: In photographing a scene including moving and unmoving objects, the photographer must determine the primary subject of the composition and direct attention to it by controlling how the motion is depicted. The young boy's reaction to the bicycle race becomes the primary subject, making the motion of the bikes secondary, but still interesting. The blurring of the bicycles leaning into the turn in the background is an example of motion that results from using a shutter speed that is slower than the relative speed of the bicycles. The primary and secondary elements in this image combine to create a compelling composition of motion and emotion.

The artist can know all the technique in the world, but if he feels nothing, it will mean nothing. Chen Chi

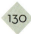

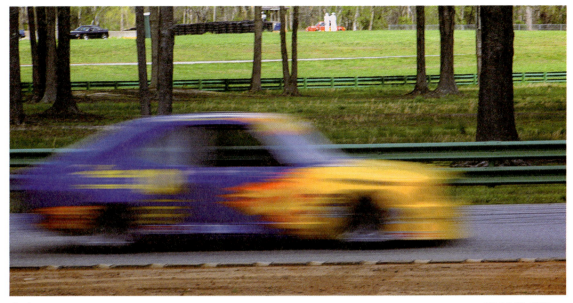

Colors *Vicki H. Wilson*

Blur: Showing movement via either panning or blurring is equally effective at conveying a sense of motion in a photograph. It is simply a matter of the desired outcome. What is the intended message for the viewer? In this image, the photographer found the bright, contrasting colors more interesting than the racecar itself and chose nonpanning with a slow shutter speed to blur the motion and to focus attention on the streaked colors. However, if the car logo or a sponsorship name were important, then panning would be necessary to direct the viewer's attention to those details that would be sharp due to the panning action at the relative speed of the car.

We affirm that the world's magnificence has been enriched by a new beauty: the beauty of speed. Futurist Manifesto, 1909

Bullfight *Howard LeVant*

If this photograph had been taken at a faster shutter speed, there would be no blur to suggest the action and movement. It was taken at a shutter speed of {1/4} of a second. Without a sense of motion, the image would be static and less interesting. A photographer is always confronted with the decision of which shutter speed will capture just the right amount of blur. This requires experience and some luck, for the action is always changing and changing fast. Distance from the subject is a factor. More distant subjects produce less blur than those up close. The opposite is true for lenses. A long focal length lens favors more blur than a short focal length lens. In this photograph, the photographer has successfully captured the movement, violence, and graceful-ness of a key moment in which the storming bull and matador have made contact. The traditional red throw serves to symbolize the potential danger in the encounter.

They call me the painter of dancers, not understanding that for me the dance is a pretext for . . . rendering movement. Degas

132

Steam Locomotive *David A. Page*

Implied Movement: How do you get an object that is as rigid and fixed as a steam locomotive to appear as if it were moving? The first thing the photographer did to accomplish this was to move in close and photograph just a section that would normally be in motion if the locomotive were moving. He used a camera with a special lens that distorts what is being photographed. In this photo, the connecting rods, which are the focal point of the image, suggest that they are in motion and causing blur. The blur suggests that the locomotive was moving at a very high speed or that the shutter speed of the camera was not fast enough to arrest the motion. The entire steam locomotive is on display at a railroad museum in Roanoke, Virginia, and has not moved in decades.

Anything that excites me for any reason, I will photograph; not searching for unusual subject matter, but making the commonplace unusual. Edward Weston

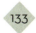

Irish Rugby Advertisement *Richard D. Zakia*

The camera captures a split second of the movement by the rugby player and invites the viewer to complete the action. The stance of the body is one that is not natural in a static position and therefore suggests movement for completion. There is just a hint of motion in the ball and hands, which evidently is moving faster than the player's body.

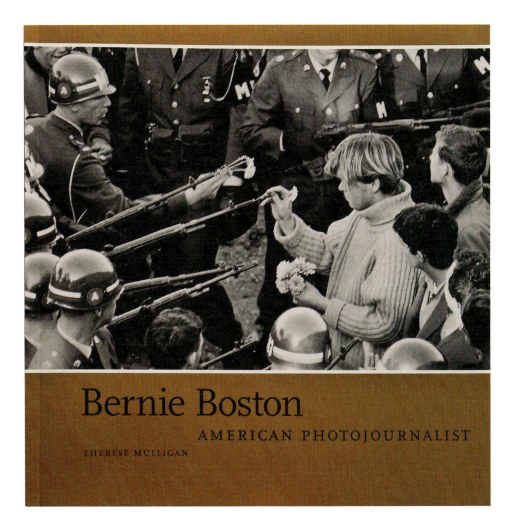

Bernie Boston's (1933–2008) photograph *Flower Power* serves as a cover for his photojournalism book. It was taken in 1967 when a group protesting the Vietnam War were confronted by a detachment of rifle-bearing National Guardsman. He captured the precise moment of a young man beginning to gently place a flower in the barrel of one of the rifles. The viewer is invited to complete the action. *Flower Power* has become his signature piece as well a cultural icon.

For a photojournalist, capturing a culturally charged event is analogous to the fortuitous alignment for celestial bodies—or so it might seem to viewers. Therese Mulligan

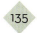

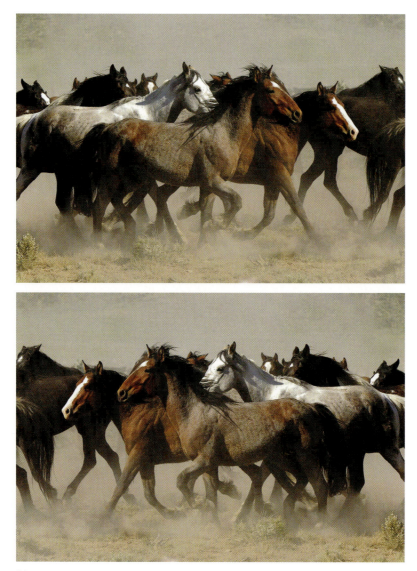

Horses

Direction of Movement: In the top photograph, the horses are moving left to right. In the bottom photograph, which has been flipped, they are moving in the opposite direction. In which photo do the horses appear to be moving the fastest? According to Dr. Rudolf Arnheim, because we read from left to right in Western society, the horses in the top photograph appear to be moving faster. In societies where people read from right to left, one can assume that the bottom photograph would appear to be the faster one.

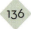

MOVEMENT EXERCISES

Looking

1. Notice how the early painter Giacomo Balla (1871–1958) used multiple images to create the sense of motion. Compare his painting to that of Marcel Duchamp's *Nude Descending a Staircase*, also painted in 1912.

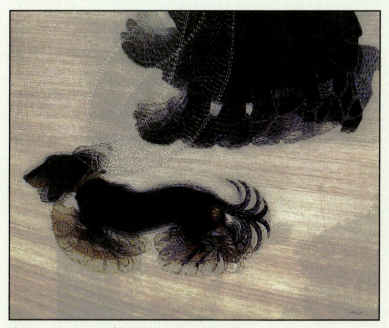

Photo 1. Dynamism of a Dog, 1912 Giacoma Balla.

2. This famous photo by Jacque-Henri Lartigue, who was both a painter and photographer, was taken in 1913, when he was 19 years old. He was using a camera with a focal plane shutter, which accounts for the racecar moving in one direction and the men in the background tilted in the opposite direction.
3. Take a look at some photographs by Harold Edgerton and Edweard Muybridge and Ernst Haas.

Photo 2. Car Trip, 1913 Jacques-Henri Lartigue.

Photographing

1. Make two photographs of moving water. One should be made at the fastest shutter speed on your camera and the other at the slowest shutter speed. You may want to try speeds in between.

Photo 3. Running Water, David Page.

2. Do the same for a moving object, such as a person, animal, or person on a bicycle. (Movement is seen as fastest when it is perpendicular to the camera.)

3. Photograph a fast-moving object by panning the camera with the moving subject while rotating your hips. Keep the subject in the middle of the camera frame. Do this several times to see how you can arrest the movement of the subject while blurring the background to suggest speed.

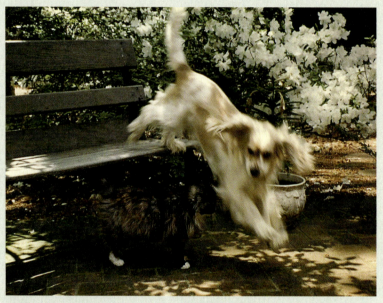

Photo 4. Bailey, Jan Page.

Camera Angle (Vantage Point)

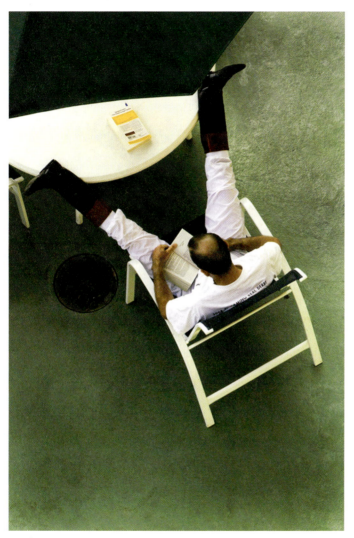

Jockey *Barry Myers*

Vantage Point High Angle (Looking Down)
Eye Level High Angle (Looking Up)
Low Angle Exercises

Vantage Point: Ansel Adams (1902–1884) and Georgia O'Keeffe (1887–1986) first met in 1929 in Taos, New Mexico, and became friends and colleagues for a long time. He was 27 years old and she was 42. They both were much attracted by the extraordinary beauty of the Southwest. He represented his version of its beauty with camera and film and she with canvas and paintbrush. In the book of their photographs and paintings, their images of the Southwest reflect their way of seeing and feeling. On the cover of their book, one can compare Adams's rendition of Saint Francis Church, Ranchos de Taos, New Mexico, with that of O'Keeffe's. The first thing to note is the different vantage point each artist used.

A good photograph is knowing where to stand. Ansel Adams

I had to create an equivalent for what I feel about what I was looking at—not copy it. Georgia O'Keeffe

School Bus Shelter *R. Zakia, D. Page*

We see here two different representations of the same subject. On the left, the photographer chose a position that included more of the area surrounding the school bus shelter, so as to provide a sense of place. To the right, the second photographer decided on a different vantage point, so as to call more attention to shelter and the movement of the flag. Both photographs were taken at approximately the same time. Each brought their own vision as to how to represent the scene. Viewers may prefer one over the other, or neither.

> Photography, as a powerful medium of expression and communication, offers an infinite variety of perception, interpretation and execution. **Ansel Adams**

143

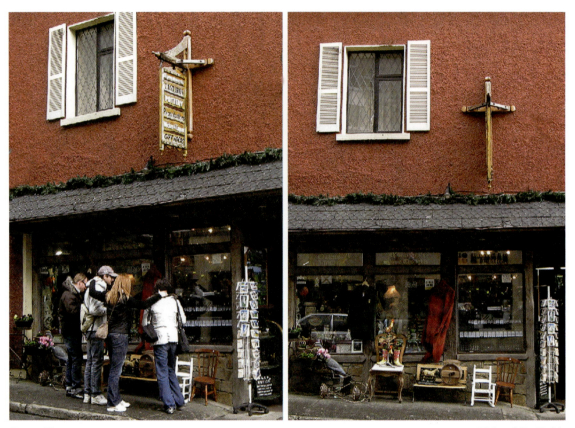

Store Front *Richard D. Zakia*

Walking by this interesting storefront's display of disparate items captured the photographer's attention—and what a surprise to see a religious symbol in the form of a large cross being prominently displayed above. This seemed rather strange at first, but it was not unusual in Ireland. After taking the photo, the photographer took a few steps back and was pleasantly reminded of the importance of vantage point.

Whenever we photograph, we see from only a single point of view. That can limit our vision and therefore our photography. Rashid Malik

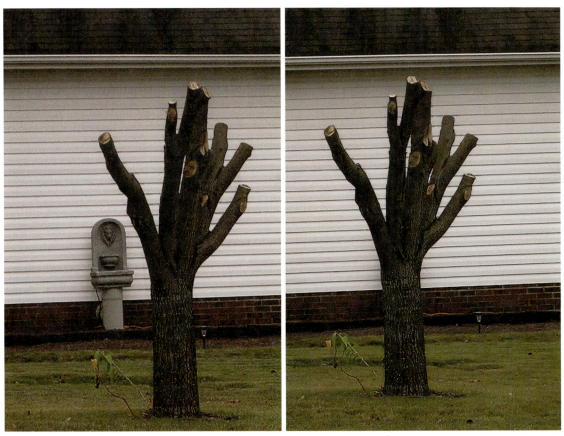

Amputated Tree *Richard D. Zakia*

Where you stand and position your camera can be useful in obscuring things in the background that would interfere and compete with the main focal point, in this case a tree that has been devastated by a recent hurricane. All that remains of the once-proud tree, deprived of its many branches and leaves, is the amputated skeleton of its former self. The photo on the left focuses complete attention on this fact. In the one on the right, it competes for attention with the sculptured piece in the background.

Everything that is visible hides something else that is visible. René Magritte

145

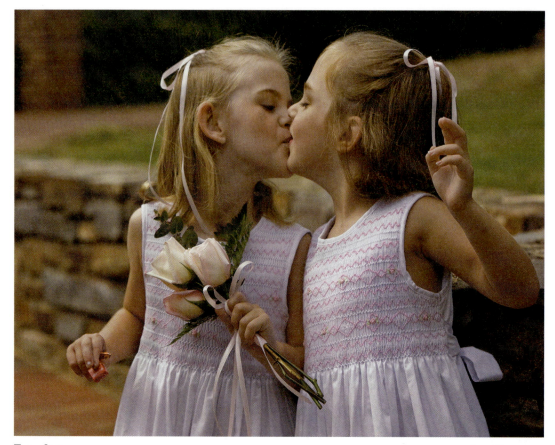

Twin Sisters *Lee Thompson*

Eye Level: When photographing a wedding, the exchange of marriage vows between the bride and groom is central, but events taking place before and after the exchange can be of great interest and add to the memories of the joyful event. In this photograph, both twins wear the same dress and hair ribbon and one holds some flowers in her left hand. The photographer instructed the girls to kiss each other, and as they did she took their photograph—not at the her normal eye level but at the twins' eye level. The lowering of the camera provided an eye-level photo that does not look down at the charming little ones but directly at them, eye-to-eye. The result is a memorable photo to include in the wedding album.

No one ever told me I was pretty when I was a little girl. All little girls should be told they're pretty, even if they aren't. Marilyn Monroe

146

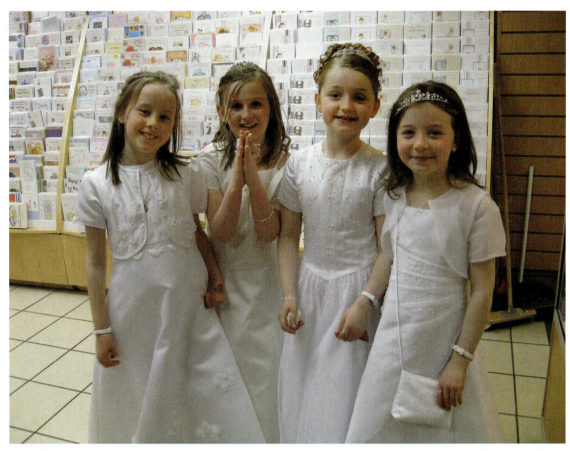

Four Shamrocks *Richard D. Zakia*

This photograph was taken at eye level and on the spur of the moment. The photographer was in a drugstore in Ireland looking for a greeting card when he noticed these four charming girls dressed in white, having just received their first communion. Their mothers were nearby and gave permission for the photograph. The girls display a joyful, angelic look and each has a similar engaging smile. The greeting cards in the rack behind them provide an appropriate background. The title *Four Shamrocks* is suggestive and open to individual interpretation.

Of all the means of expression, photography is the only one that fixes a precise moment in time. We play with subjects that disappear; and when they're gone, it's impossible to bring them back. Henri Cartier-Bresson

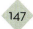

147

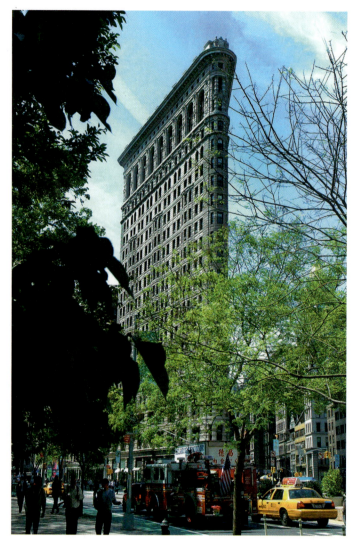

Flatiron Building *David Spindel*

This photograph was taken a block away from an impressive and often-photographed New York City building. The photographer used a camera having an 18mm lens, holding the camera at eye level. The building was completed in 1902 and is one of the first skyscrapers ever built.

In any architecture, there is equity between the pragmatic function and the symbolic function. Michael Graves

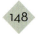

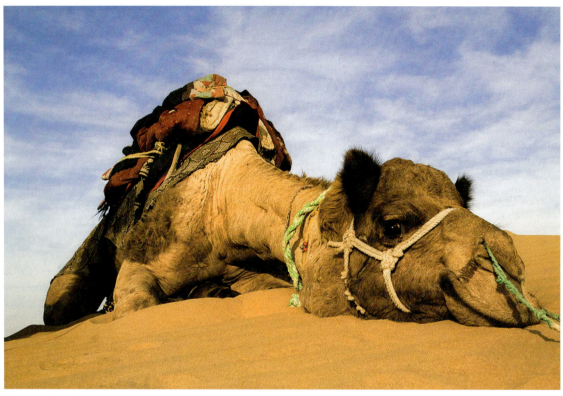

Dromedary Camel

Low Angle: In this photograph of a one-hump dromedary camel, the photographer set his camera very low, nearly touching the sand mound. We thus have an up-close and intimate look at the camel as he lies on the sand. His expressive face is located approximately at the imaginary rule of thirds' lower-right intersection, providing a strong composition. The camel's face becomes the center of interest and the focal point of the photograph. The color of the camel and sand are similar and contrast well against a blue fluffy sky. Dromedary camels are one of the best-known members of the camel family. Other members include llamas and alpacas in South America. Unlike the Dromedary camels, the Bactrian camels have two humps.

My photographs are not planned or composed in advance and I do not anticipate that the onlooker will share my viewpoint. However, I feel that if my photograph leaves an image on his mind—something has been accomplished. Robert Frank

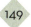

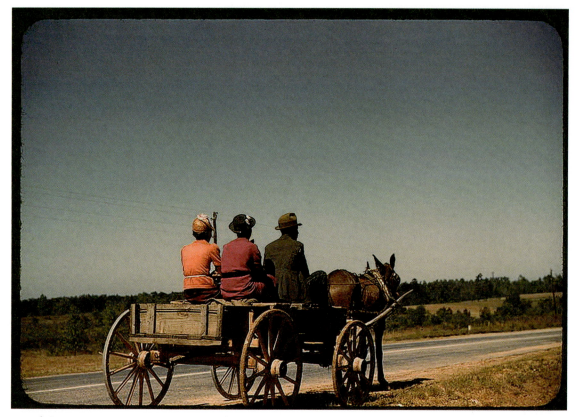

Rural Georgia *WPA photograph*

This Work Progress Administration (a government agency as part of America's New Deal in the 1930s) photograph shows three folks all dressed up and going into town for what appears to be an important event. Although they ride on an old farm work wagon pulled by a mule, suggesting their meager status, they dress proudly and sit up straight as they journey. Compositional elements of interest are: a somewhat low vantage point; the framing, which allows room for the wagon to move within the frame; the diagonal position of the wagon, suggesting movement; the low horizon line, providing a large stretch of beautiful blue sky; a group of three, which is more interesting than two or four. Photographing the backs of the three in the wagon allows the viewer to vicariously experience what it might be like to ride on such a wagon and on the dirt alongside the paved road as cars and trucks pass by. The stark simplicity of the composition plays up the contrast between the reality of the times and the spirit of the times.

Samba *Richard D. Zakia*

High Angle, Looking Down: Photographing dogs can be as difficult as photographing children. They won't hold still and have a tendency to change positions just as you are about to click the camera shutter. This was the case when trying to photograph Samba. Every time the camera was pointed at her, she felt prompted to move. After several frustrating attempts, this was one that succeeded. She lies comfortably on a plain, textured carpet, one paw stretched near the ball she was playing with and the other paw tucked in. The position of her body is graceful as she inquisitively looks up at the camera and therefore at the viewer.

The greatest pleasure of a dog is that you may make a fool of yourself with him and not only will he not scold you, but he will make a fool of himself too. **Samuel Butler**

151

Score *David A. Page*

Photographing from a high (or low) angle provides a different view from the norm, which in itself attracts the attention of the viewer. In the case of sports photography, as illustrated in the previous photograph, this angle of view often provides a clearer perspective of the action and includes more information about the actions of a greater numbers of players. In a straight-on photograph, often an important part (or all) of one player will be blocked by others. The same is true when photographing flowers and other objects. Additionally, a high angle of view often provides a more pleasing and less distracting background. When photographing a box-like subject such as a car, church, sculpture, house, and so on, the most interesting photographs are made at approximately a 45-degree angle from the front, side, or top surface, which enhances the feeling of the third dimension.

By photographing a group from an elevated position, all members of the group can be better seen in the photograph. **V. Hutto**

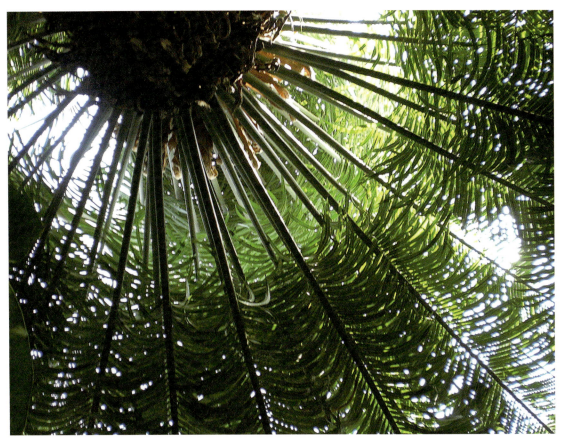

Nature's Umbrella *Lydia Zakia-Fahey*

High Angle, Looking Up: There are times when one is looking up to photograph something that can make for an unusual and interesting picture. Lydia was sitting on a bench in a park with her mother and digital camera waiting for her friend to arrive. As she looked around for something to photograph, she happened to look upward towards the beautiful blue sky and notice the attractive underside of a palm tree. Rather than attempt to show the whole underside of the tree, she chose to show just part and located the dark center of the branches in the upper left of the frame, which made for an interesting composition and photograph.

The central act of photography, the act of choosing and eliminating, forces a concentration on the picture edge—the line that separates in from out—and on the shapes that are created by it. John Szarkowski

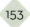

EXERCISES

Looking

1. Julia Margaret Cameron (1815–1879) took many portraits, some of famous people. This eye-level photograph with turned head is of 16-year-old actress Ellen Terry. *Sadness* was photographed in 1864 and is an interesting play of light and shadow. Look at some of Cameron's photographs in books and on the Internet.

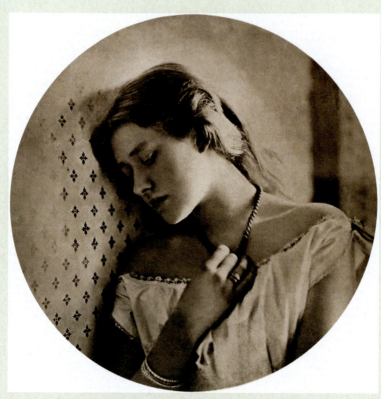

Photo 1. Sadness. Julia Margaret Cameron.

2. Arnold Genthe (1869–1942) took this photograph from a high level on Sacramento Street to show the thunderous fire, devastation, and damage of the San Francisco earthquake of 1906. More than 3,000 people lost their lives in the tragedy.

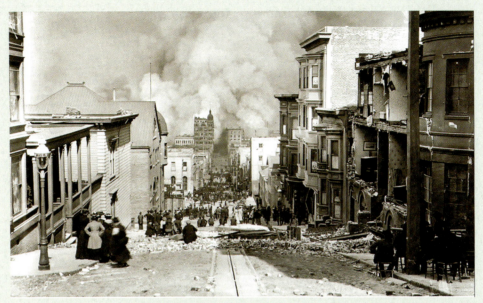

Photo 2. San Francisco Earthquake. Arnold Genthe.

Photographing

1. Choose a subject of interest and photograph it from three different vantage points. Which best represents your subject, and why?
2. Take a photograph of a person with your camera at eye level and then looking up and looking down. Compare the three different photographs in terms of what they convey.

8

Gestalt Composition

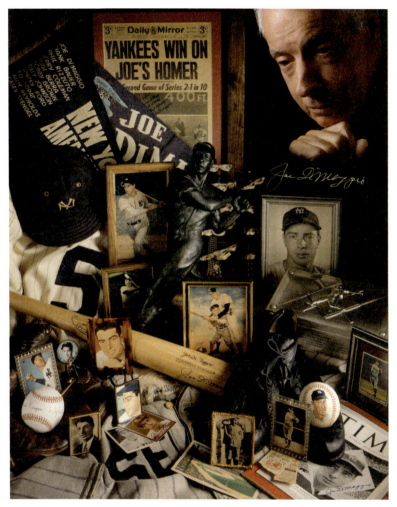

Joe DiMaggio *David M. Spindel*

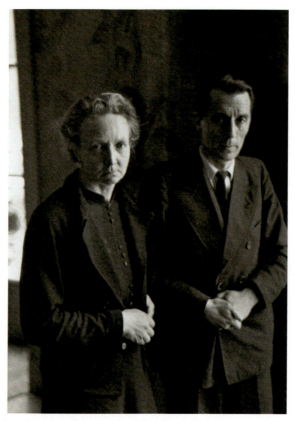

Irene and Frederick Joliot-Curie (Magnum Photo) *Henri Cartier-Bresson*

Similarity: Things that are similar in size, shape, color, movement, and so on will be seen as belonging together and grouped as a unit. In this black-and-white photograph by Bresson, two prominent French scientists who are husband and wife are similarly dressed in dark clothes, have similar expressions and similar lighting on their faces, and hold their hands in a similar fashion. They are easily seen as a unit, and as the saying goes, couples who have been married for a long time begin to not only act alike but to look and sound alike. Madame Curie was born in Poland and later became a French citizen. In 1903 she won the Nobel Prize in Physics and in 1911 the Nobel Prize in Chemistry. She was a pioneer in the field of radioactivity and the first person to be honored with two Nobel Prizes. In 1898 she named the first new chemical element that she discovered *polonium*, for her country of origin.

Similarity is a prerequisite for noticing differences. Rudolf Arnheim

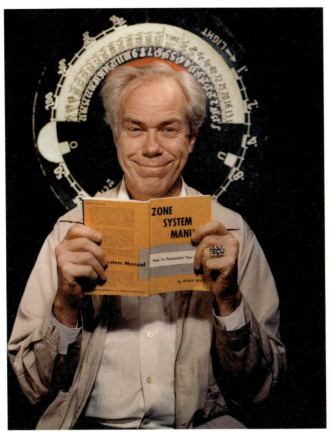

Minor White *David Spindel*

Proximity: The closer two or more things are, the greater the chance that they will be seen as a unit, group, or pattern. Minor White holds his yellow Zone System book in both hands and his head is centered in front of a large mock-up of a Weston Meter dial that he used to teach the Zone System. The nearness of Minor's head to the large dial is such that head and dial are seen as a unit and belonging together. Spindel was Minor's student at the Rochester Institute of Technology (RIT). Minor sent a copy of the photograph to his friend Ansel Adams and Ansel wrote Minor that it was the best photo he had seen of him and that he looks angelic.

Proximity is the simplest condition of organization. We hear words in verbal coherency, primarily because of the temporal proximity of their sound elements. Gyorgy Kepes

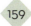

Jungbauer Westerwald, 1914 *August Sander*

Similarity and Proximity: Three young German farmers in similar dark suits and white shirts stand posed, looking directly at the camera and photographer. The distance (proximity) between the man on the left and the two on the right is essential for the arrangement. It can be thought of as an interval, providing a more interesting composition than if all three were grouped without the interval. Although the men are dressed alike, they are dissimilar in how they present themselves. The two men on the right have a similar pose, but the one at the left does not. The dissimilarity keeps the composition from being static. His hat and cane are tilted, a cigarette dangles from his mouth and his expression is a bit different. Similarity, dissimilarity, proximity, and interval all work together in this outstanding photograph.

Mozart said at one point, that he wasn't so much interested in notes as the space between them. Harley Parker

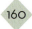

Peruvian Children *Fatima NeJame*

Similar things in close proximity are easily grouped as a unit, as we see here. All five girls are in similar dress and are close to each other. An interval separates the three girls at the left from the two to the right, but all are seen as belonging. One can imagine a right triangle with the three girls, which in itself makes for a strong grouping. Dissimilarity in size between the three girls and the two to the right adds interest, as does the way that the smaller girls are directly engaging the viewer while the two taller girls are looking off to the right. The background provides a setting without diminishing the attention given to the girls.

To take photographs means to recognize—simultaneously and within a fraction of a second—both the fact itself and the rigorous organization of visually perceived forms that give it meaning. It is putting one's head, one's eye and one's heart on the same axis. Henri Cartier-Bresson

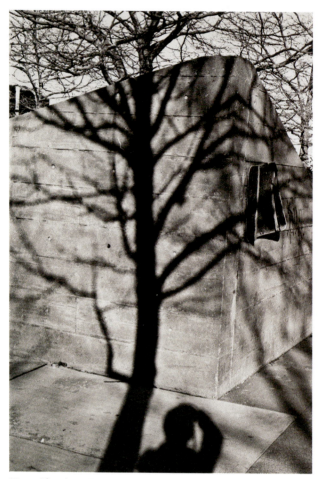

Tree Shadow Tree *Richard D. Zakia*

Continuation: The eye prefers to follow things that have the least amount of change or interruption. Notice how the eye follows the shadow of the tree trunk as it continues up the wall and connects with the top of the tree trunk on the other side of the wall. The eye movement is continuous and is not interrupted by the spread of shadows of the branches on the wall or the branches at the top of the tree. For the eyes to follow any one of the branches requires a change in direction. In a sense, the eye follows the path of least resistance.

The eye appears to act according to the principle of least effort and do no more than is imposed on it. Floyd Ratliff

162

Del Mar, California *Barry Myers*

Closure: We have a tendency to want to complete familiar things (shapes, forms, lines, and so on) that are nearly complete but not. In this photograph of a trainer pointing his finger at a colorfully dressed jockey, the finger almost touches the jockey's nose but does not. We, however, automatically see the photograph as needing completion and do so by closing the gap between the finger and the nose. If the distance (interval) had been greater, would we still have completed the implied movement and formed closure? Probably not, for the width of the interval is critical for completeness. Our mind is primed to complete what is incomplete and seeks to do so—we participate in the event and are rewarded. (Mary had a little lamb, her fleece was white as . . .).

Of all the means of expression, photography is the only one that fixes a precise moment in time. We play with subjects that disappear; and when there gone, it's impossible to bring them back to life. Henri Cartier-Bresson

163

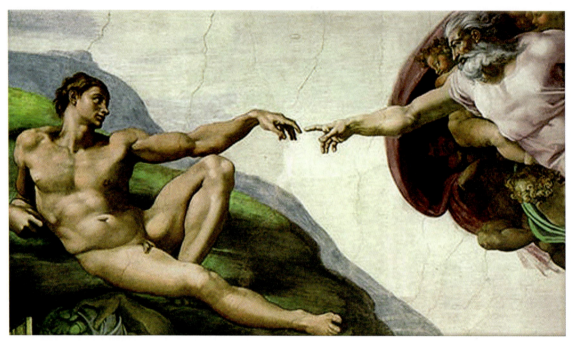

The Creation of Adam *Michelangelo*

In this famous and familiar painting by Michelangelo, God the creator at the right extends his finger to give life to Adam, who also extends his finger to receive life. The fingers do not touch, however, and life has not yet been given. It is up to the viewer to activate the action by having the fingers touch. By doing so, we complete the action and form closure.

The size of the interval between the fingers (proximity) is critical: if it were too large, the connection would be weakened. If there were no interval and the fingers were touching, the painting would be static and not alive, awaiting completion by the viewer.

Without an interval there would be no music. Rashid Malik

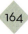

Korean Memorial *David A. Page*

Notice, again, the importance of the interval in this photograph of the Korean War Veterans Memorial in Washington, DC. The chosen vantage point created the interval that separates the lead soldier from the rest. He looks intensely ahead as the others follow and look off to the side for potential enemies. A high camera position was needed to avoid the road and tourist buses just behind the memorial. The memorial brilliantly captures the hardship and mood of combat soldiers on patrol in enemy territory. The statues are just over 7 feet high and represent men from each branch of the military: Army, Marine Corp, Navy, and Air Force.

My objective, always, is to stay as close as possible and shoot the pictures as if through the eyes of the infantryman, the Marine, or the pilot. I wanted to give the reader something of the visual perspective and feeling of the guy under fire, his apprehensions and suffering, his tensions and releases, his behavior in the presence of threatening death. David Douglas Duncan

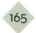

Untitled *Andrew Davidhazy*

When you first look at this photograph, you might puzzle for a moment wondering what it is a picture of. The blurriness provides a feeling of movement and action but parts of the photo are missing. A couple of clues, blurred ball and sneaker, help to identify that it as a photo of a tennis player swinging and hitting a tennis ball. But where is his face or head? Because of the vantage point from which the photo was taken, all we "see" is the top of the head, which is a dark blur and appears to be missing. Once the photo is identified for what it suggests, however, closure takes place and we see and can feel the fast action and movement of the player—we participate in the photo and event. If the photo had been captioned "Tennis" would you have seen it more easily at first? Probably so, for a caption becomes part of the photo, part of the gestalt.

The creative act lasts but a brief moment, a lightning instant of give-and-take, just long enough for you to level the camera and to trap the fleeting prey in your little box. Henri Cartier-Bresson

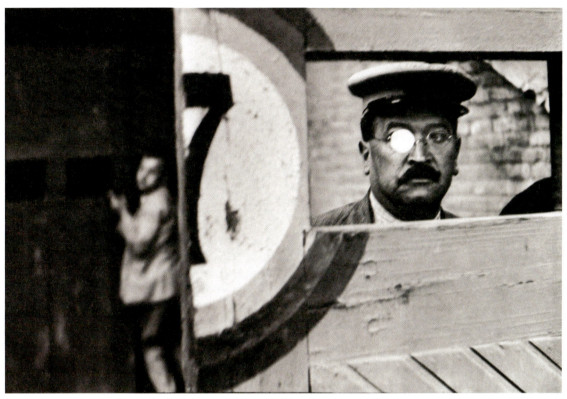

Roman Amphitheatre, Valencia, 1933 (Magnum Photo) *Henri Cartier-Bresson*

Bresson's photograph *Roman Amphitheatre, Valencia, 1933* can be seen as an example of similarity, proximity, continuation, and closure. The man's white spectacle and large, white half-circle are similar in color and shape and in close proximity. One is invited to continue the circular movement on the large number 7 target to form a closure on the half-circle. Note how the lower, dark portion of the circle easily connects with the edge of the man's jacket to facilitate the continuation. Cartier-Bresson made at least seven photographs of this subject setting and chose to publish only the one shown here because the various elements of this image work together to form a strong gestalt.

To photograph is to hold one's breath, when all faculties converge to capture fleeting reality. It's at that precise moment that mastering an image becomes a great physical and intellectual joy. Henri Cartier-Bresson

EXERCISES

Looking

1. Take another look at Bresson's photograph *Roman Amphitheatre, Valencia, 1933*. He chose this photograph from several others he took from the same vantage point. It is an engaging and puzzling photo. Though the man and boy are near each other, they appear to be a different distances because of scale. Without some information on what was photographed, it remains a puzzle. Actually, you are looking at the entrance of a bull-fighting arena. In the middle of the photo, is a large sliding door, numbered 7, which is partially open. On either side of the door, spectators can peer through rectangular windows, as this man does. The ambiguity of the photograph lends itself to prolonged looking. Look at some of Bresson's other photos in his many books and at Magnum.com. He was a master not only of the "decisive moment" but also of composition.

Photo 1.

2. Did you happen to see a wine bottle when you first looked at this clever ad (Photo 1)? It is not surprising, for we are programmed to want to form closure on familiar things.

3. One of Weston's favorite photographs was *Nude 1936* (Photo 2). The model (his wife Charis) was positioned just to the left of center. The light falling on her was very bright. When she ducked her head to rest, Weston told her to hold that pose. Her face is not seen, just the top of her tilted head, with the hair clearly parted and at an angle. Following the contour of the right side of her left arm, one discovers that it continues as it coincides with the parted hairline. Other continuing contour lines can be easily seen in this line drawing of the photograph. The photograph can be seen on the Internet. Create line tracings of some well-known photographs and some of your own, to study their structure and composition.

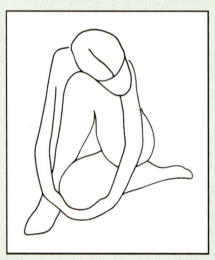

Photo 2.

4. Gestalt portrait, *The whole is greater than the sum of its parts.* The Italian painter Giuseppe Arcimboldo, who was a court painter in the 1500s, created many imaginative portraits, such as the one titled *Emperor Rudolf II as Vertumnus*. He is widely copied—the Kikkoman ad being one example. You can find his fascinating work on the Internet. (In Roman mythology, Vertumnus was the god of seasons, and could change his form easily.)

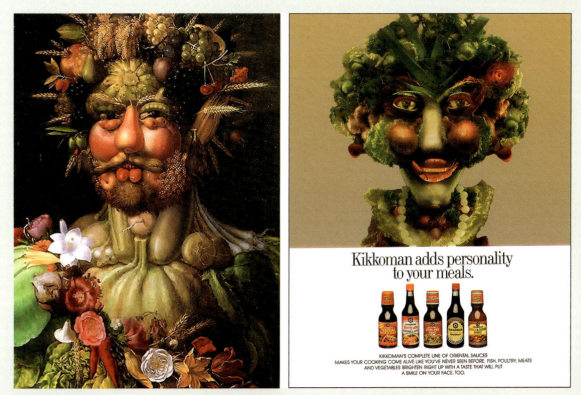

Photo 3 and 4.

Photographing

1. Gather a bunch of flowers or fruits and vegetables and try arranging them in such a way as to form a gestalt and then photograph them. The photograph in the ad pays homage to a painting by Arcimboldo.
2. Look for objects that are in close proximity and have similar or dissimilar colors and some that have complementary colors, and photograph them.

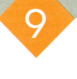

Portraiture

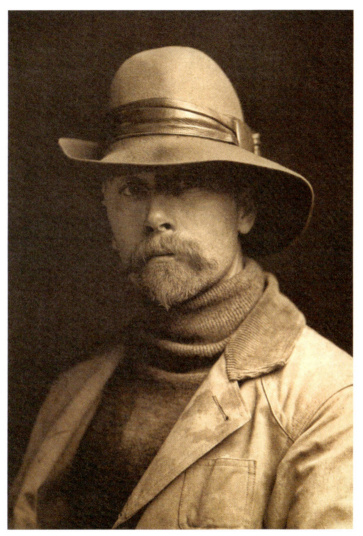

Self Portrait. *Edward S. Curtis*

Formal	Camera Distance
Informal	Pupil Size
Environmental	Exercises

Portrait: Miss N *Gertrude Kasebier*

Formal: What constitutes a good portrait? First and foremost, it must show more than what a person looks like. It must show his or her personality—who the person really is. This portrait does just that. It is a 1902 photograph of a young, attractive, and sensual showgirl, Evelyn Nesbit. She is very much at ease, as we can see from her engaging facial expression and body position. She reveals herself to us as she is.

There is no single form or style of portraiture. Portraiture means individualism and as such means diversity, self-expression, private point of view. The most successful images seem to be those which exist on several planes at once and which reflect the fantasy and understanding of many. Peter Bunnell

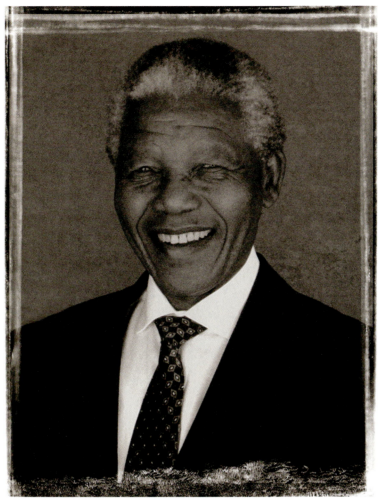

Nelson Mandela, 1994 *Harrison Funk*

This is a test print the photographer made to check the lighting on his subject before taking several additional photographs. Of the photos that were taken, he chose the test print. It had captured Mandela in a relaxed moment and with a natural-looking smile. The border around Mandela serves as a remnant frame that the photographer decided to keep as such. At another level, it can be seen as symbolic of the prison confinement he was subjected to for many years.

I think what makes a picture is a moment that is completely spontaneous and natural and unaffected by the photographer. John Loengard

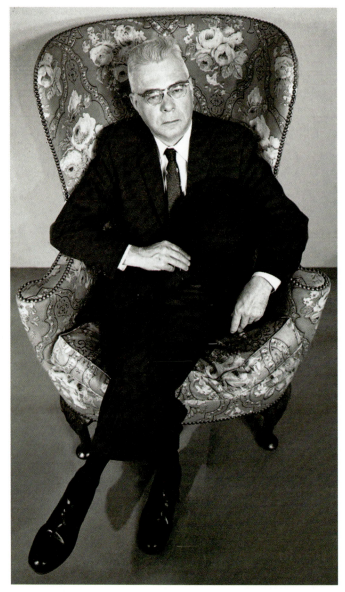

C.B. Neblette *David M. Spindel*

In this full-body portrait, the man sits comfortably in a patterned chair that set off his formal dark attire. The camera position is slightly elevated, which has him looking up a bit. He is very much at ease, with legs crossed and hands occupied with a bowler hat and a cigar. The photo has a natural look to it.

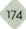

First Couple *David A. Page*

Informal: Here we have a full-body portrait of two people, former president Jimmy Carter and his wife Rosalynn. Considerable planning went into this shot in preparation for their appearance on the Duke campus. The photographer had only a short time to take the photograph. The couple appears to be comfortable with each other and the photographer as he photographed them. Their facial expression and body positions are relaxed and the background provides a somewhat classical setting. It is interesting to compare the photograph of this married couple with that of Madame Curie and her husband in the Gestalt section of this book.

Lois Ann Arlidge *Richard D. Zakia*

Although the lady in this image is formally dressed with a white hat, white gloves, white purse, the photograph is an informal outdoor portrait captured with natural light. She is positioned slightly off-center and the photo was taken slightly below eye level. (The photographer was shorter than the subject.) She has a natural engaging smile, with the left side of her face illuminated by sunlight and the right side in the shadow. The background has a rustic look and is slightly out of focus so as not to call attention to itself.

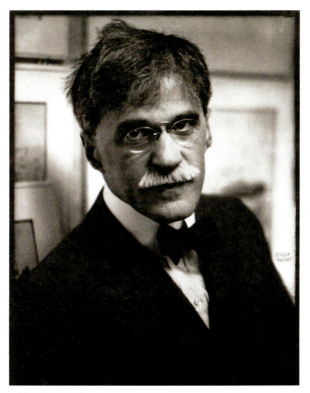

Alfred Stieglitz, 1915 *Edward Steichen*

Environmental: Lighting is very important in every kind of photography, and in a portrait of a man, it is often a strong light to emphasize manliness. This is not always the case, however, as we can see in the somewhat soft lighting on the Neblette and Curtis photograph. Steichen's portrait of his friend Stieglitz taken at eye level has him looking straight at the viewer with his head slightly titled to the left and his right shoulder at an angle. This provides a more dramatic look. The photo was taken in Stieglitz's New York gallery, as is evident from the out-of-focus background. The portrait is tightly cropped, which emphasizes the importance of the sitter.

Success in photography, portraiture especially, is dependent on being able to group those supreme instants which pass with the ticking of a clock, never to be duplicated—so light, balance—expression must be seen— felt as it were—in a flash the mechanics and technique being so perfected in one as to be absolutely automatic. **Edward Weston**

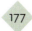

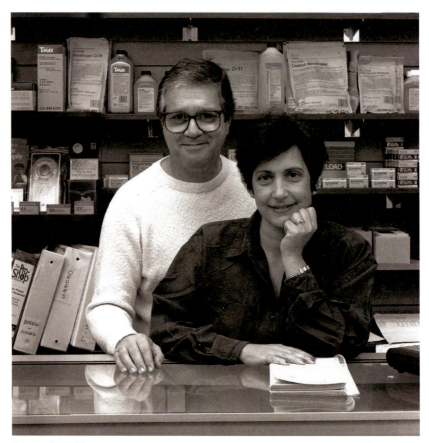

Photo Pro Shop *Arnold Newman*

Arnold Newman who specialized with environmental photographs used only available light for this photograph. He arranged his two subjects so that they were slightly off-center to the right. They are grouped in such a way as to form a classic triangle. The man in the white sweater provides a strong contrast for the woman in the black blouse. Their hands are resting to add to a relaxed posture. The couple is at ease and make good eye contact with the photographer and the viewer. Both project an engaging smile. The background provides a setting and is slightly out of focus so as not to compete with the couple.

I am always lining things up, measuring angles, even during this interview. I'm observing the way you sit and the way you fit into the composition of the space around you. Arnold Newman

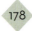

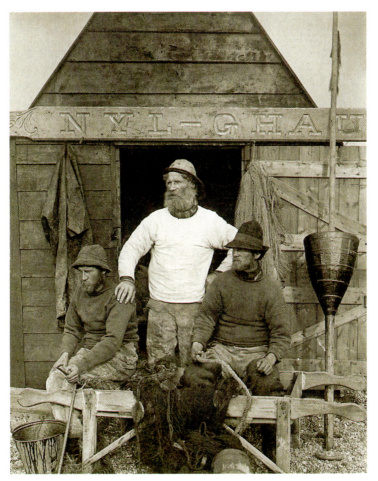

East Coast Fisherman *P.H. Emerson*

In this early outdoor environmental portrait, the photographer positioned the three fishermen in the center of the frame looking off to the left as if waiting for a boat to arrive. The three of them form a triangular shape and the middle one, in a white sweater, contrasts strongly against the black surround. Part of the top of the fishermen's shack is cut off, suggesting another triangular shape. There is great detail and information in the photograph, calling attention to the tools of their trade and the rugged outfits they wear.

I like things that have to do with what is real, elegant, well presented and without excessive style. In other words, just fine observation. **Elliott Erwitt**

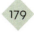

179

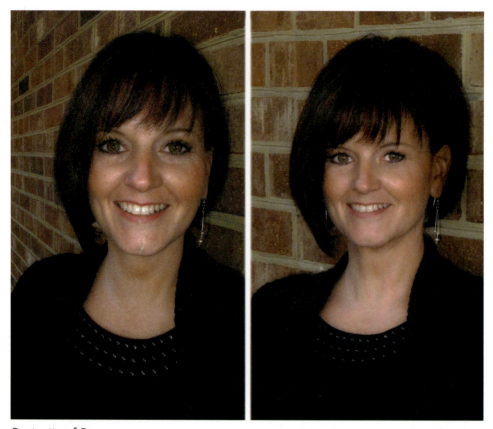

Portraits of Pam *David A. Page*

Camera Distance: The most pleasing portraits are made when the photographer is a distance from the subject. In the example, above right, the photographer was more than 10 feet from Pam using a lens with an equivalent focal length of 150 mm for a 35mm camera. The camera was less than two feet from the front most portion of the subject on the left. A 28mm lens equivalent gave the same relative face width as the image on the right. Because a face is curved more horizontally than vertically, the face appears to be "longer." The increased angle of view of the shorter lens makes the wall, which is at an angle to the subject, appear to "fall away faster." Many professional portrait photographers use a 35mm camera lens equivalent of more than 200mm, which requires a camera-to-subject distance of more than 10 feet in order to flatten out the face and reduce the "nose effect." A remote release allows the photographer the ability to be close to the subject for better communication and still allow for a camera-to-subject distance that creates a most pleasing portrait perspective.

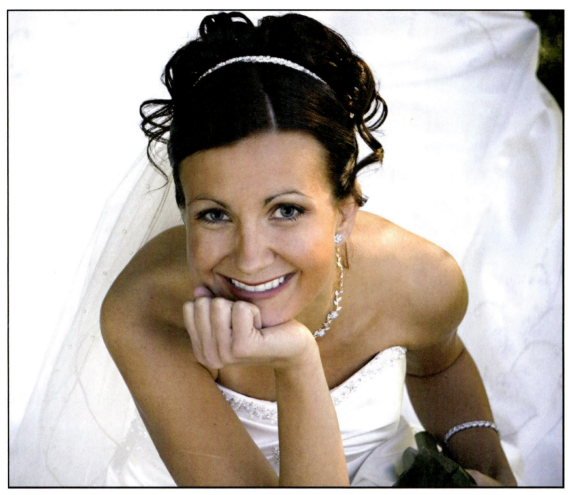

Bride

Pupil Size: In this close-up portrait, the bride looks directly at the camera and viewer. The top part of her body leans slightly forward with her face resting comfortably in the palm of her left hand. Her wedding dress provides a white background that blends with the front part of her dress, calling attention to her upper body. The large pupil size of her eyes is a sign of excitement, research has shown. It is an automatic response. Some portraits are now Photoshopped so the pupils look larger to reflect interest.

Our brains are programmed to respond to eyes and faces, whether we are consciously aware of it or not. Melissa Bateson

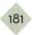

PORTRAITURE EXERCISES

Looking

1. James Van Der Zee (1886–1983) was an African American photographer who had a studio in Harlem and created portraits of African Americans of his time. He was affectionately called "The Picture Taking Man."

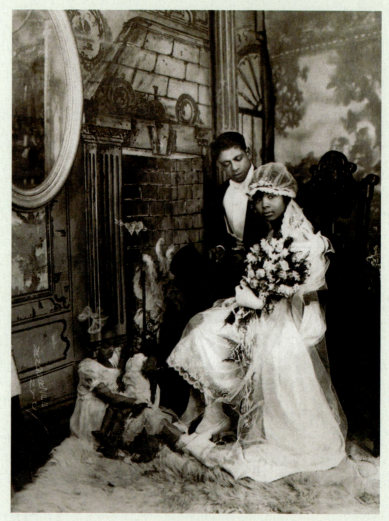

Photo 1. Future Expectations. Photo by James Van Der Zee.

2. Between 1920 and 1940, Nickolas Murray made over 10,000 portraits of movie stars and other celebrities. In this photograph, the movie star is positioned to the left of center with a prominent left shoulder, geometrically arranged arms, and a strong gaze at the viewer.

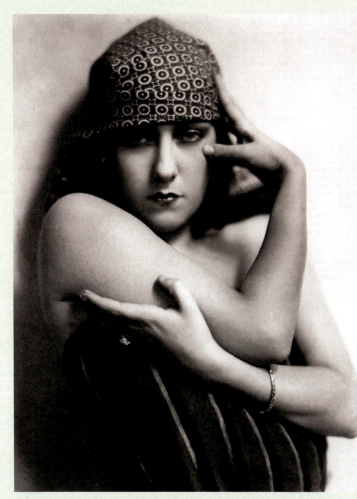

Photo 2. Gloria Swanson, 1922. Photo by Nickolas Murray.

3. Compare the lighting and expression of Edward Curtis's self-portrait with that of Nelson Mandela and Alfred Steiglitz.
4. Look at other photographs by Van Der Zee and Nickolas Murray as well as those by others such as Nadar, Arnold Newman, Yousuf Karsh, Judy Dater, Gordon Parks, and August Sander.

5. Comment on this profile portrait by Hugh Magnum, an early North Carolina traveling photographer. Make a statement about the lighting, the position of the woman within the frame, and the darkness around the eye area.

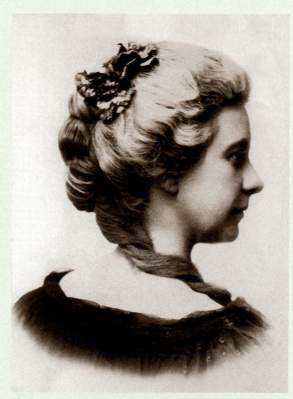

Photo 3. Penelope. Photo by Hugh Magnum.

Photographing

1. Take a formal and informal photograph of the same person and compare them. Does one better portray his or her personality better than the other?

2. Pupil size is important in a portrait. Take a photograph of a friend and make a print. Then use Photoshop to increase the pupil size and make another print of the same size. Place the two prints side by side and ask friends which they prefer.

3. Using the same photograph, change the pupil size of only one eye and show it to friends to see if they detect that there is something strange with the portrait and notice the difference.

4. Take a photo of a friend and ask him or her to smile and then take one without the friend smiling. Which do you prefer? (It is difficult to fake a smile, as it is an automatic reflex requiring the involuntary contraction of muscles. To be able to successfully fake one requires much practice, as actors and politicians have discovered.)

5. Working in pairs, have one person be the photographer and the other the model. The photographer positions herself, ready to take a photograph of the model, who holds a piece of paper or pencil in his hand. When the model feels relaxed and ready to have his photo taken, he drops the paper or pencil. This is an exercise that Minor White used when he was teaching at R.I.T.

6. Try taking a self-portrait of yourself by looking into a mirror. In this way, you can study your expression before you click the shutter. The screen at the back of digital cameras allows you see the result immediately. To make your portrait, first adjust the zoom to include enough space around your image so aiming the camera is not critical. Use the maximum resolution, because you will crop the image later to remove anything you do not want in the final portrait. Portraits made using a mirror will be laterally reversed—that is, the left and right sides are switched. This can be corrected in an image-editing program by using the "flip horizontal" command.

Photo 4. Mirror Self Portrait by Irving Pobboravsky

Light and Shadows

Direct Light: Direct lighting illuminates by striking an object without scattering, as does the sun on a clear day. This creates strong colors, highlights, and shadows. The many contours and shapes of St. Basil's Cathedral are well defined by the position of the light source (the sun) over-head and to the right of the subject. When the position of the sun is at a low angle, direct light can have a very dramatic effect on the subject. This is why for some subjects such as landscapes, professional photographers prefer to photograph a few hours before or after high noon when the sun is at a low angle, to produce good frontal illumination and long cast shadows.

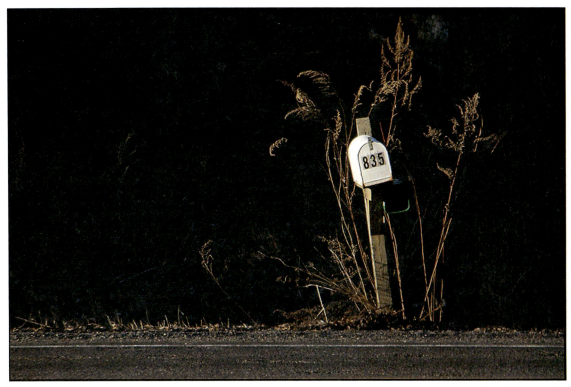

Sympathetic Leanings *Irv Pobboravsky*

One need not travel to distant places to capture the dramatic effects of direct lighting. As the impact of low-level sunlight on the mailbox in this photograph attests, any object properly illuminated can result in a commanding photograph. Yogi Berra said it well: "You can observe a lot just by watching"—and here, we could add, by watching the light on an object change throughout the day. The painter Claude Monet did just that by painting the changing light on haystacks. The paintings were not so much about haystacks but rather a study of how light through the day and seasons of the year alter the way haystacks are seen. In an extended study of light on the same object, Monet did some 30 paintings of the Rouen Cathedral in France. Imagine what the photograph of St. Basil Cathedral, on the previous page, might have looked like under the same condition.

For me, a landscape does not exist in its own right, since its appearance changes at every moment; but the surrounding atmosphere brings it to life—the light and the air, which vary continually. Claude Monet

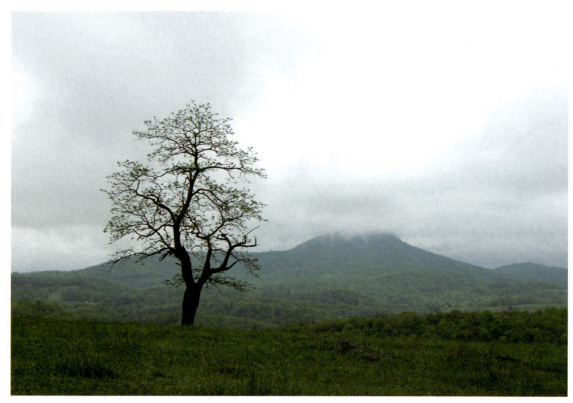

Lone Tree *Richard D. Zakia*

Diffuse Light: Often, amateur photographers think that in order to make good outdoor photographs, the sun must be shining and it must be a clear day. Sunny conditions can produce very dramatic effects through the interplay of highlights and shadows, but the photographer should not overlook the value of shooting outdoors on an overcast day. Landscapes can take on a serene quality under diffuse lighting conditions, such as in the mountain scene here. The rich green color of the foreground and variable shades in the background are due to the soft lighting. The lone tree in this composition would stand out in either a direct or diffused lighting condition, but the diffused light from the low-ceilinged cloud mass hovering over the mountain peak creates a backdrop that accentuates the forlornness of the bare-limbed tree. Any photographer wishing to capture true colors in nature should enthusiastically grab camera equipment, dash outside, and shoot a favorite landscape on an overcast day. The results will not disappoint.

Color, as the most relative medium in art, has innumerable
faces or appearances. Josef Albers

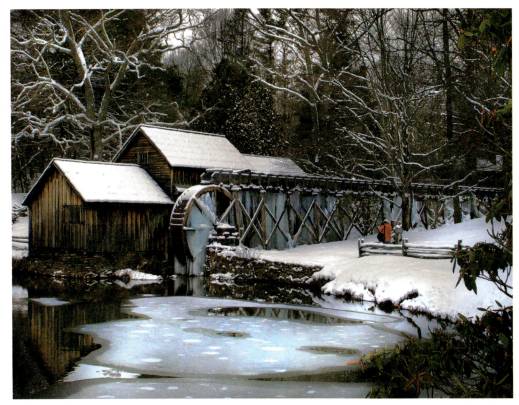

Mill in Hibernation *David A. Page*

Adverse weather can provide opportunities for interesting photographs. Rain, snow, stormy skies, and other severe weather conditions can make memorable images for a number of good reasons. Such unfavorable weather presents the scene in a way that it is normally not viewed by most people, as they would not venture out to see it. In this photograph, isolation, freezing cold temperatures, and eight inches of heavy snow made travel to the mill very difficult. Bad weather is usually accompanied with diffuse light and soft shadows. The red of the second photographer's coat adds color and scale.

Photographing in the rain also has its own special merits. The low contrast is more than compensated for with the clean rich colors, which pop out when objects being photographed are wet. In fact, commercial photographers will often wet down their subject before making the image. Additionally, an angry sky makes a great background for an interesting landscape. Special care must be exercised in order to operate, protect, and preserve the photographic equipment and, even more importantly, the photographer.

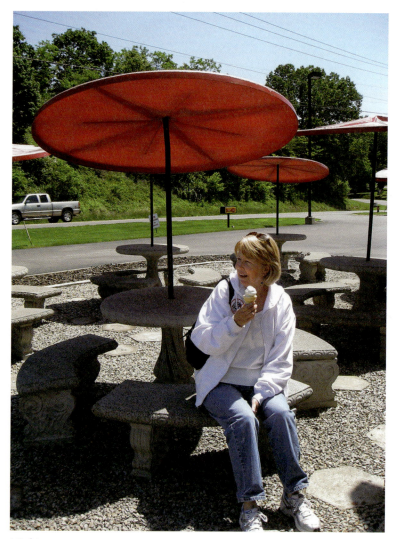

Vicki *Richard D. Zakia*

Direct/Diffuse Light: This impromptu composition attracted the photographer because of the effects created by a combination of direct and diffused lighting. The umbrella diffuses the sunlight, which otherwise would have created harsh reflections off of the concrete table and benches and subsequent hard lighting on the subject's face. At the same time, strong shadows provide interest to the composition without distracting from the main subject.

Mabry Mill, Virginia *David A. Page*

Lighting was the most important element in making this photograph. The camera location was chosen to enhance the setting of the mill. Most images of this frequently photographed spot on the Blue Ridge Parkway are simply a document of the mill. Waiting for the heavy fog to lift on an early fall morning was the key to making this successful photograph. In a heavier fog, the sharp detail in the foreground trees that frame the mill and pond would have been muddled. By photographing before the fog had cleared, the dreamlike, soft quality of the mill and background was maintained. The curvature of the edge of the pond in front of the mill serves as a concave lead line, guiding the eye to the mill.

The way I would describe a pictorial is that it is a picture that makes everybody say "Aaaaah," with five vowels when they see it. It is something you would like to hang on the wall. The French word "photogenique" defines it better than anything in English. It is a picture, which must have quality, drama, and it must, in addition, be as good technically as you can possible make it. Alfred Eisenstaedt

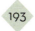

Galloping Horse

Back Light: *Backlighting* is created when the subject is positioned between the light source (natural or artificial) and the photographer. The sun-drenched clouds of dust in this photograph provide a soft but dramatic backlight for the galloping horse. The thin outline created by backlighting on a subject helps to separate the subject from the background and emphasizes fine details, such as the horse's mane, that could easily be lost with front-directed lighting. The subject (horse) and the background (dust clouds) are equally important because of the effects of the backlighting in this composition.

Backlighting dramatizes the subject, but it also can overpower the composition to become the subject itself. Sometimes this is intentional, notably in sunrise and sunset compositions that tend to silhouette foreground landscapes. Backlighting is challenging because the exposure must be calculated carefully to provide sufficient lighting on the subject surface that faces the camera (away from the backlight source) to provide sufficient detail, as in the horse in this photograph. A lens hood is helpful for controlling lens flare from shooting directly toward the light source.

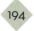

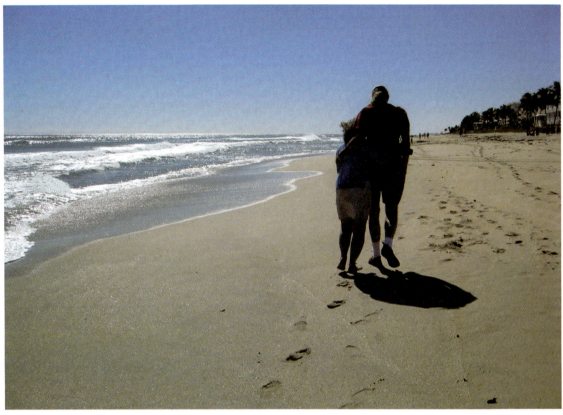

Shared Moment *Richard D. Zakia*

The beach provides a pleasing but challenging location to photograph people. On an overcast day, subjects on the beach can appear hazy and washed out, and on a bright sunny day the glare from the reflections off of the water can overpower the subject. This image works well, based on the photographer's decision to shoot from behind. Had the couple been walking toward rather than away from the camera then the natural expectation would have shifted attention to their faces, which would be in deep shadow, thus disappointing the viewer. As taken, this composition preserves the true subject of the composition: the intimacy of the couple, which is more interesting than their identity. The lighting effects of brightly reflective water, cast shadow, and subtle highlights off the shoulders and hair enhance rather than detract from the mood of the composition.

Trust that little voice in your head that says "Wouldn't it be interesting if" And then do it. Duane Michals

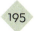

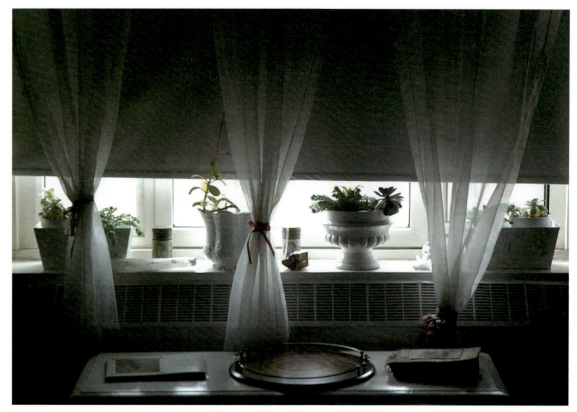

Homage to Minor White *David Spindel*

The soft light establishes the mood in this photograph, and mood controls the viewer's response. This composition is entirely about the quality of light. The strong diffused window light creates a pleasing tension while preserving a sense of tranquility through well-defined use of shadow, highlight, and texture. Had the photographer raised the window shades, even slightly, or turned on room lights, the mood would have been destroyed, rendering the composition mundane and inconsequential. The table in the foreground helps provide a sense of depth. The arrangement of the potted flowers and three curtains are well balanced within the frame.

When I looked at things for what they are, I was fool enough to persist in my folly and found that each photograph was a mirror of my Self. Minor White

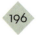

196

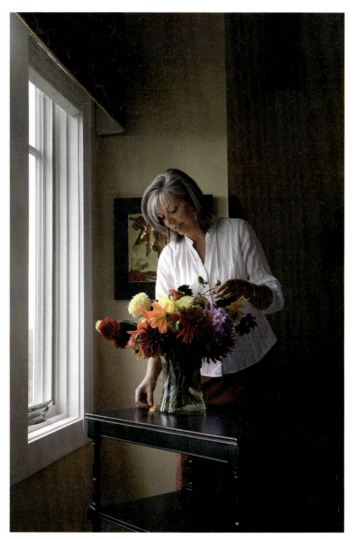

Homage to Vemeer *Vicki H. Wilson*

Window Light: Famous seventeenth-century painter Johannes Vermeer was the inspiration for this composition. Vermeer is known for his use of bright colors, interior settings, and—most importantly—subjects illuminated by window light. This photograph successfully incorporates those same elements in the colorful flowers and the soft window light, highlighting the slightly down-turned face of the subject. The choice of white blouse was deliberate, to ensure additional bounce light onto the subject's face. Even the high-ceilinged room is reminiscent of a Vermeer setting.

EXERCISES

Looking

1. Vermeer (1632–1675) was a Dutch Baroque painter and a master at using soft window light in his paintings. Carefully study his rendition of light and shadow on his subjects and their surround, the way he positioned his subjects and the props he used.

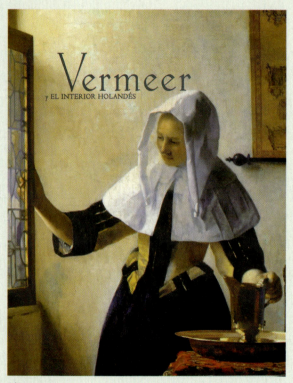

Photo 1.

2. Study the dramatic use of light and shadow in the painting *Wanderer in the Storm* by German painter Carl Julius von Leypold (1805–1874). It portrays a storm-swept dark landscape and projects the feeling of a person's loneliness and the temporary changes in nature and life.

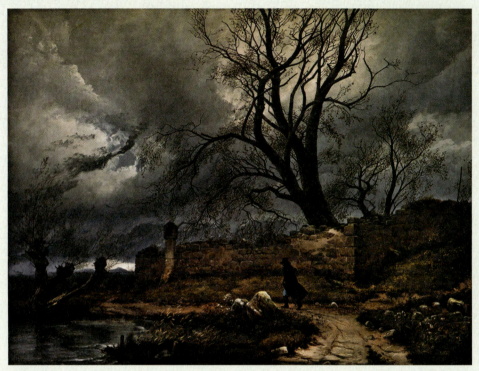

Photo 2.

3. Study some other paintings by Albrecht Durer, Goya, El Greco, and Rembrandt, and photographs by Ansel Adams, Wynn, Bullock, Yousuf Karsh, and Arnold Newman.

Photographing

1. Create your own *Homage to Vermeer* as Vicki Wilson did.
2. *Chiaroscuro* (dark–light) lighting is sometimes referred to as *Rembrandt lighting*. Look at some of his portrait paintings and try creating the same effect using a single light source such as a large window light.
3. Have fun with your shadow and project it on a brightly lit nonflat surface as we see here in Photo 3.

Photo 3.

4. Photographing something during inclement weather, as we have seen with Dave Page's *Mabry Mill* covered with snow, can provide interesting and unusual photographs. If you live in an area where there is no snow, photograph something during a rainstorm. Have someone hold an umbrella over your camera.

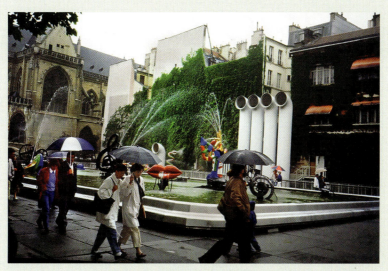

Photo 4.

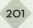

Color, Colour, Couleur

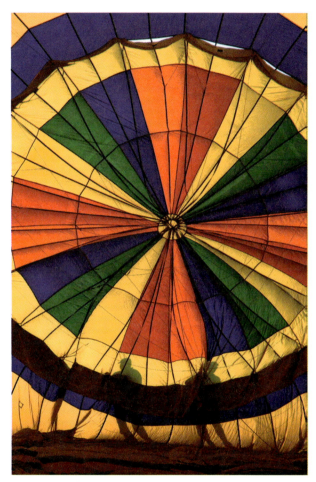

Hot Air Balloon *David M. Spindel*

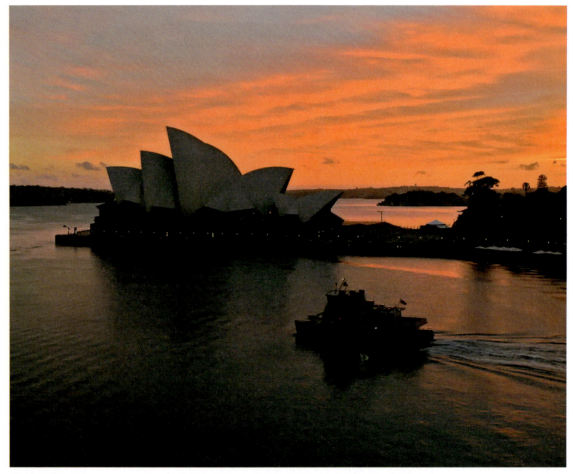

Early Morning *Arnold Drapkin*

Warm Colors: The elements in this sunset photograph of the opera house in Melbourne, Australia, are serene on one level and competitive on another. If the photograph were taken at night or during daylight, the building would have commanded full attention. But the oranges of the sky and reflections in the water, along with the contrast of silhouetted landmass, compete for attention with the internationally recognizable shape of the opera house. Instead of becoming just another photograph of a well-known landmark, the photographer's timing in shooting this image makes the sunset the subject and the famous landmark a supporting player. The boat moving from right to left and leaving behind a wake provides an interesting lead line.

All of our knowledge has its origin in our perceptions. **Leonardo da Vinci**

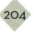

Blue Boat *David A. Page*

Cold Colors: The analogous cool colors in this photograph create soothing harmony. However, most interestingly, this photograph is given a touch of drama with the ever-slight inclusion of complementary red. Though the bright blue boat grabs our immediate attention, the red draws the viewer into the composition's foreground. Additional interest is conveyed by the tonal variations in the seaweed, which add depth and detail to the composition. The placement of the boat in the frame is at an angle and follows the rule of thirds. Lesser diagonal elements in the seaweed direct the viewer's attention from the lower corners to the boat.

The whole world, as we experience it visually, comes to us through the mystic realm of color. Hans Hofmann

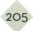

Muted Colors *David A. Page*

Soft Colors: The beauty in color lies not just in its intensity but also in its delicious subtleties, as in this landscape. The gold and small touches of orange of the tree and the minimal greenery offer delicate contrast against the neutral foregrounds and backgrounds, instilling a feeling of peace and calm. There are times when shouting is the correct thing to do and times when a whisper can actually speak louder. If this image had the same color contrast as the very successful image on the right, the image would have failed. The soft and finely detailed background of this image allowed a tree with little color contrast to stand out strongly from that background. The viewer in time seeks out details passed over at first glance.

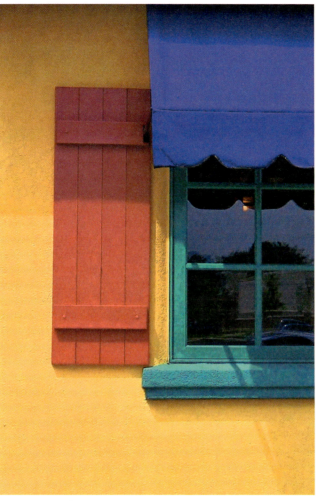

Mimi's Window *Vicki H. Wilson*

Strong Colors: This photograph's combination of complementary primary colors in large proportions makes a clearly bold statement. While the viewer sees the window, the way in which the photographer cropped the image says that the composition is not about the window—it's all about the colors that just happen to take the shape of a window.

You're working with composition and the colors. The subject is not everything. **William Eggleston**

Cirque de Soleil *Michael Geissinger*

Complementary Colors: The complementary bright yellows in this blue composition adamantly define the subject. The viewer perceives immediately that these are colorful circus tents with a host of international flags flying and the French flag to the far left. The yellow trash cans easily connect with the yellow strips of the tent, which are well positioned in the frame providing a feeling of balance.

The people in the dark foreground give scale to the tents. The contrasting bright yellow and blue tents against the lighter blue tones in the sky project a feeling that something fun and exciting is taking place, regardless of whether that's really happening.

Color! What a deep mysterious language, the language of dreams. Gauguin

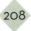

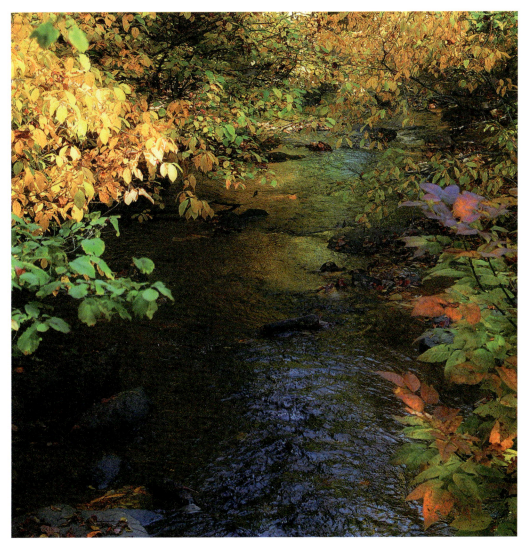

Watercolors *David A. Page*

Color is a strong compositional element. Water is in itself colorless, but is great at reflecting the colors of the sky and surrounding leaves, which perform as natural filters. In this photo, the original colors reflecting off the water were in the shade and therefore subdued. Lightening and restoring normal contrast using appropriate software makes the image "pop."

Color is a means of expressing light. Henri Matisse

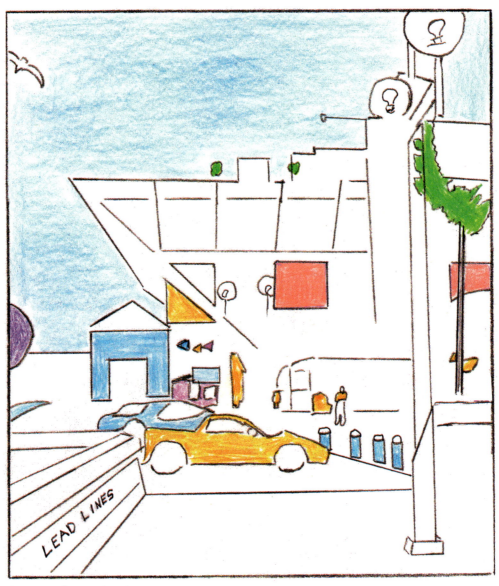

St. Petersburg, Florida *Vicki H. Wilson*

Color Harmony: Harmony describes the color interaction in this photograph of the St. Petersburg pier on a clear Florida day. In addition to the colors, the photographer was attracted by the lines and shapes within the composition.

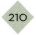

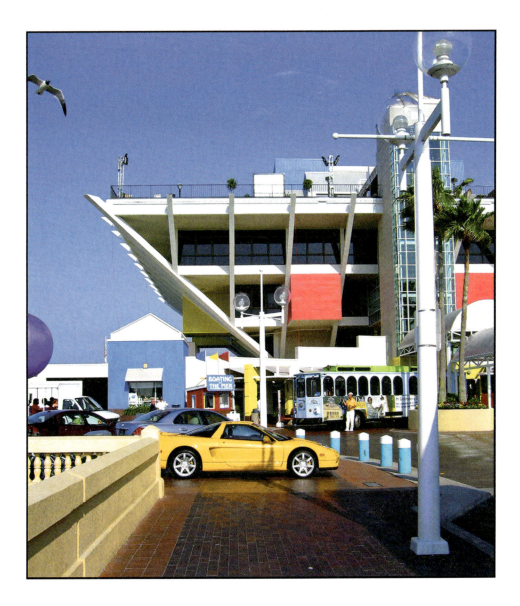

Throughout the image, shapes, and colors play against one another: the arched windows of the tram and the rounded tops of the painted concrete abutments in the foreground, the yellow sports car and the shirt of the man standing next to the tram, and the angles of the neutral tones of the building and sea wall railing. Even the purple half-sphere complements the glass globes atop the lampposts.

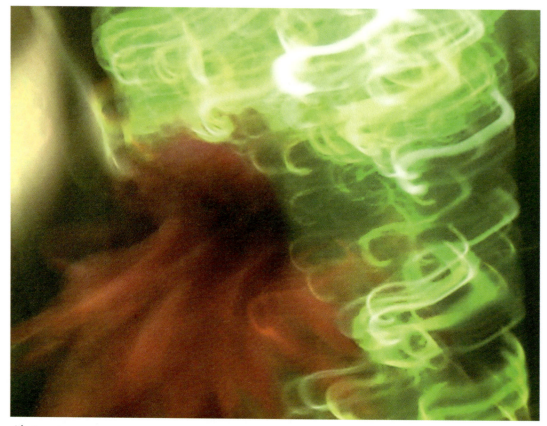

Abstract *Lydia Zakia-Fahey*

Abstract Color: This photograph is interesting on several levels. It incorporates the complementary hues of red and green with tonal variations and saturation. The shadows emphasize the highlight streaks, effecting a three-dimensional look, while the red wispy area conveys a sense of motion. But consequently, it's left to the viewer's imagination to identify the subject matter, if even so desired. It's certainly not necessary. Color triggers both emotional and psychological responses in all of us. Red, for example, can represent both love and danger. We tend to interpret cool colors (blues, greens) as soothing and calming, and warm colors (yellows, reds) as inviting and energizing. Bold colors impart a sense of strength, power, and drama; subtle colors convey quietness, solemnity, and tranquility.

For me form is never abstract. It is always a sign of something. It is always a man, a bird, or something else. Joan Miro

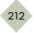

212

EXERCISES

Looking

1. Pete Turner has been a master in the realm of color photography over the past 50 years. Look over and study his dynamic use of color and composition on his web site, http://www.peteturner.com, and in his books. His recent books are *African Journey* and *The Color of Jazz Album Covers* with a foreword by Quincy Jones.

I've always been inspired by geometric shapes. Pete Turner

Photo 1. Direction. Pete Turner.

2. Rick Sammon is an outstanding photographer, author, teacher, and lecturer. He works primarily in color and across cultures, and reminds us that "Cameras don't take pictures, people do." Spend time on his web site, http://www.ricksammon.com, and look at his photos in many of his books. Two of his most recent books are *Rick Sammon's Digital Photography Secrets* and *Face to Face*, a book on how to photograph people.

Photo 2. Carnevale, Venice. Rick Sammon.

3. Additional books you may want to check out are *The Color of Wilderness* by Eliot Porter and *William Eggleston's Guide* by William Eggleston, with an introduction by John Szarkowski.

Photographing

Contrasting Colors

1. Photograph two objects in close proximity that have strong contrasting colors, such as yellow and blue. The yellow should enhance the blue color and vice versa.

Similar Colors

2. Create a still-life photograph using colors that have similar or adjacent hues, such as those found on a color wheel. Consider some of the warm colors—yellow bananas, lemons, oranges, and red apples, and so on, as well as flowers and other things of similar colors.

Dominant Color

3. Have one object stand out among other colors, such as a child wearing a bright red cap in a landscape of green, or a red boat against blue water.

Fireworks

4. Try photographing a burst of colors against a dark sky at the peak of the burst so as to capture an interesting pattern of colors, or the shape of a single color, such as the heart we see here. A slow shutter speed was used so that several of the burst "blossoms" could be captured as one image.

For other images by Page, go to http://www.david-page-photography.com.

Photo 3. Valentine. David A. Page.

SECTION THREE: After Capture

Print Captions/Titles

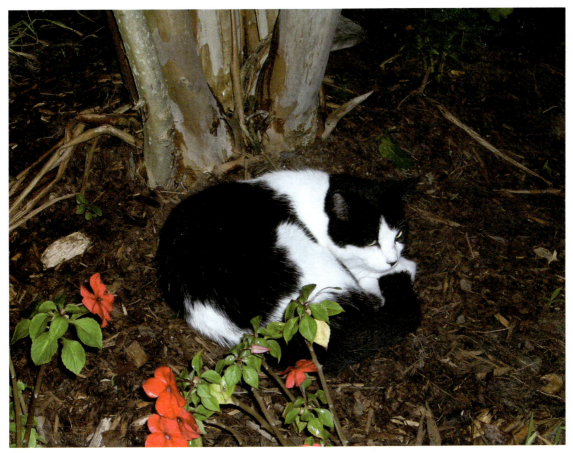

Ginger *Lydia Zakia-Fahey*

Generic	Narrative
Specific	Poetic
Suggestive	Untitled
Ambiguous	Exercises

A caption is part of the photograph, part of the gestalt. Rudolf Arnheim

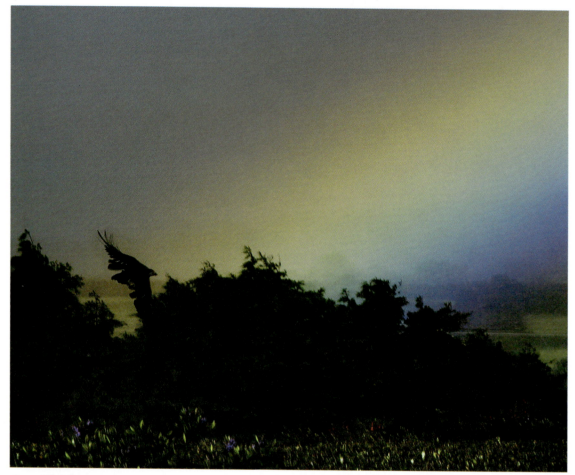

Beautiful Day *David A. Page*

A Parable: *A blind man with no legs sits in a park begging. A sign beside him reads HAVE COMPASSION. I AM BLIND. People walk by and ignore the sign, the man, and his hat, a receptacle for coins. A well-dressed businessman walks past him, turns around and stands in front of the man. He picks up the sign, writes something on the back and places it back where it was and with what he wrote showing. People continue to walk by but now are dropping coins and bills into his open hat. The blind man is thrilled and collects the money. When the businessman returns, the blind man asks him what he wrote on the sign. He replies that what he wrote was TODAY IS A BEAUTIFUL DAY AND I CANNOT SEE IT.*

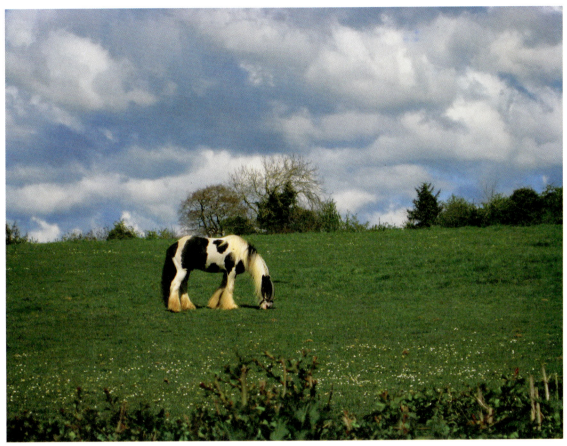

Horse *Richard D. Zakia*

Generic: By captioning this photograph "Horse," it could be any one of a class of such horses. The caption makes the horse the main subject—not the landscape or the location in Ireland.

The title is usually the last thing for me . . . I like to be simple and not too instructive or definite. Maggie Taylor

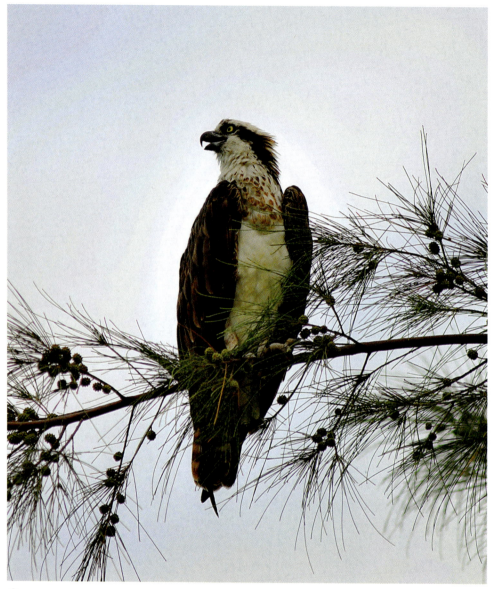

Osprey *Mike Cantwell*

Specific: The caption identifies the type of bird for those not familiar, who might mistake it for an eagle.

Suggestive: *Guarding the Nest.*

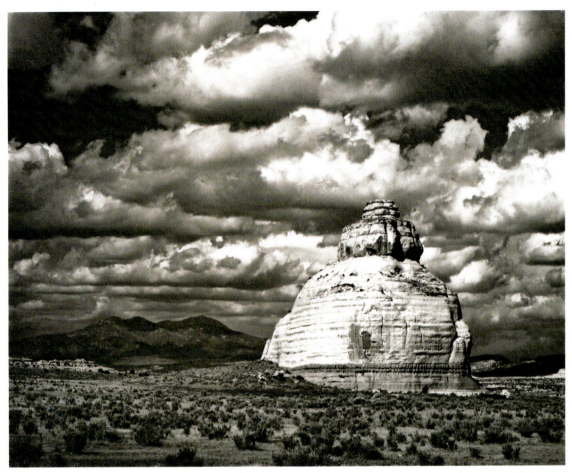

Equivalent *Thomas L. McCartney*

Ambiguous: One might ask what the subject in the photograph is equivalent to. Stieglitz used the word to caption cloud photographs that, for him, were equivalent to a feeling they instilled. Such a title is usually subjective and personal.

Specific: Round Butte, Route 191-Utah

Quote: "Rock of Ages" could be of interest here and be associated with a familiar phrase.

Pieces of text [captions/titles] . . . can simplify, complicate, elaborate, amplify, confirm, contradict, deny, restate, or help define different types of meanings when they interact with images and objects. Sean Hale

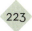
223

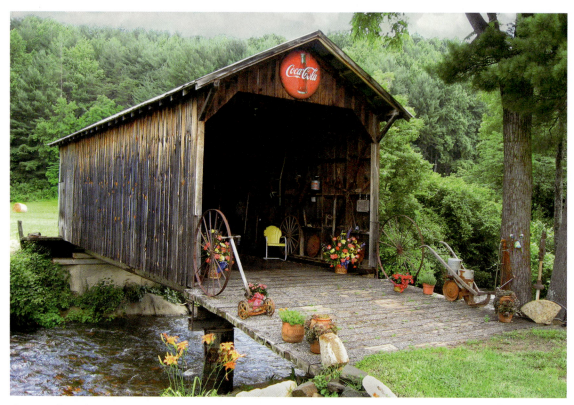

Covered Bridge

David A. Page

Generic Caption: *Covered Bridge*

Specific Caption: *Clarence Woods Covered Bridge, Woolwine, Virginia*

Ambiguous Caption: *In remembrance, John Woods Shelton 1991–2009*

Narrative Caption: *Just one week after his high school graduation, the great-grandson of the builder of this bridge, John Woods Shelton, died in an automobile accident as he returned from his Myrtle Beach celebrations. His family mourned in seclusion for two weeks, but had an obligation to open this bridge on their ancestral property for the Woolwine Covered Bridge Festival. As it was a major playground area for the deceased and the center point of many of his happy days, the family decorated the bridge with the brightly colored flowers from his funeral and placed a bright yellow chair where he often sat as a child listening to the river and contemplating a future that was not to be.*

Lewis Hine

Poetic Caption:

The golf links lie so near the mill
That nearly every day
The laboring children can look out
And see the men at play

Sarah N. Cleghorn (1876–1959)

(*Hine's note for this photograph:* Rhodes Mfg. Co. Spinner. A moment's glimpse of the outer world. Said she was 11 years old. Been working over a year. Lincolnton, N.C.)

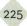

Flowers *Richard D. Zakia*

Question: Captions can be used to raise a question. In this case, is this a photograph of flowers? Is a dandelion a flower? Most would probably say "no"; some might say "yes." What defines a flower—color, beauty, fragrance, rareness? A botanist would describe a flower as a seed-bearing part of a plant surrounded by bright colored petals.

There are always flowers for those who want to see them. Henri Matisse

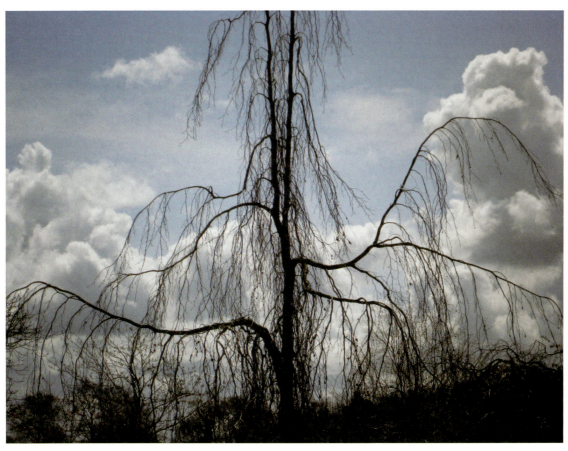

Untitled, 18, 2009 *Richard D. Zakia*

Untitled: Some photographs are labeled *Untitled* so as not to direct or influence the viewer's response. The paradox is that by titling the photograph *Untitled,* it is given a title. However, it does provide a way to identify photographs. A friend who is a recognized fine art photographer and has a PhD in art history was asked whether he captions his prints or titles them. His reply was that he titles them, but that most are untitled with a number and date. Dictionaries seem to be unclear as to the difference between a title and a caption. The best distinction found was by a linguist who said that a caption is a definition, or an explanation while a title is a suggestion. A title for this photograph could have been *Tree of Sorrow* or *Weeping Branches*.

EXERCISES

Looking

1. Refer to the famous photograph taken at the end of WWII by Alfred Eisenstaedt of a sailor grabbing and kissing a nurse (see Geometric Chapter 1). The photo graced *Life* magazine and quickly became a cultural icon. Not so well known is a similar photo taken at the same time by U.S. Navy photojournalist Victor Jorgensen (Photo 1). From a compositional point of view, it is interesting to compare the two to see why the Eisenstaedt photo better captures the momentous event. From a captioning point of view imagine, for a moment, how a caption such as *Sexual Harassment* would change the whole meaning of the photo. Captions become part of the photo and the meaning derived.

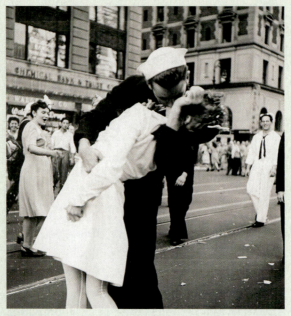

Photo 1.

2. Title one of your photographs that friends have not seen *Untitled* and ask two of them to comment on it. Then ask two different friends to comment on the same photo but with a different title—one that is ambiguous. You may want to continue using new friends and other titles that are suggestive, specific, poetic.
3. Look at this early photograph by Gordon Parks (Photo 2) of a U.S. government charwoman, Ella Watson, and provide a caption that reflects your feeling as you study it. The photo was taken for the Farm Security Administration (FSA) in the 1930s. Parks said he had posed her Grant Wood–style before the American flag.

Photo 2.

4. Provide a *caption* for David Page's photograph of a barn (Photo 3) and also a *title*. Think of a caption as defining the photo and the title as what the photograph might be suggesting.

Photo 3.

5. Poetry and painting had a strong influence on Duane Michals. His photographs contain narratives and are presented in a sequence to tell a story or to raise philosophical questions. Walt Whitman's poetry has had a great influence on his work, as have Eastern religion, surrealism, and artists like René Magritte and Joseph Cornell. Look at some of Duane Michals's photographs, in books and on the Internet, that have narrative captions.

Photoshop, Syntax, and Semantics

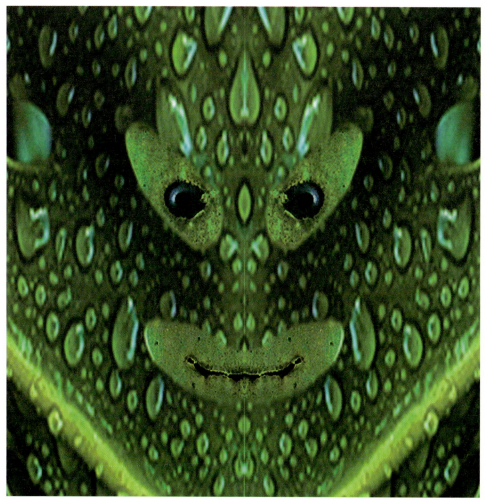

Woodland Pixie *J. Thomas Bullington*

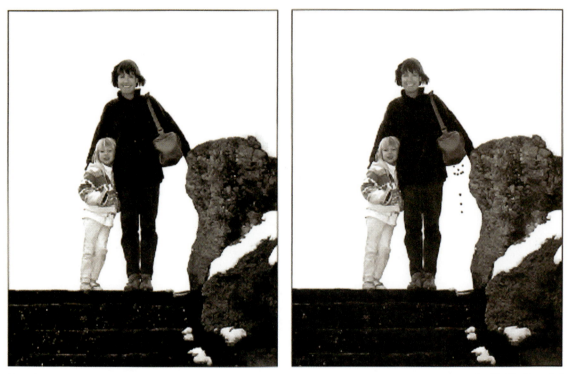

Frosty *Leslie D. Stroebel*

Add Something: By adding something to a photograph or subtracting something from a photograph, the syntax is altered and therefore the meaning (semantics) changes. The photographer took this casual snapshot of his daughter and granddaughter. It was a cold wintry day, as can be seen by the way the subjects are clothed, the snow in the rock crevices, and the blank sky. Later, upon looking at the photograph, he saw the white space between his daughter and the large rock as a potential snowman. By adding a few black spots for a face, it emerges from the background and becomes part of the subject. The grand daughter was full of joy over the photograph and proudly showed it to many of her classmates. The simple addition of some strategically placed black dots altered the syntax and gave the photograph an extended meaning.

It is only when the figure has emerged from the ground and developed into a contoured whole that attachment of meaning, naming, and consequent changes in what is perceived can occur. N.F. Dixon

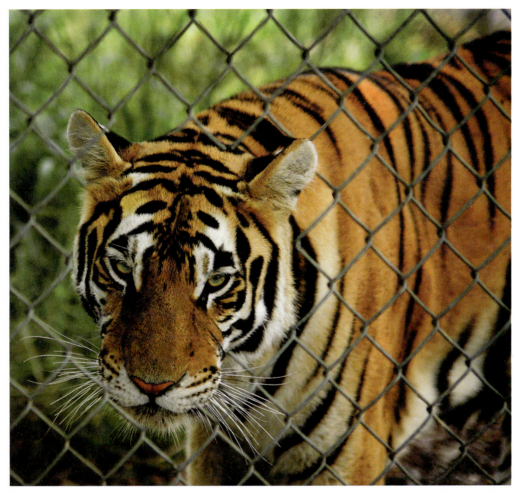

Tiger *David A. Page*

Subtract Something: This image was the result of many hours of cloning in Adobe Photoshop. When photographed, this cat was completely behind a fence. The option to bring the camera lens up to the fence and shoot through an opening was prohibited in this case, but has worked well in the past. Careful cloning away part of the fence produced an unexpected illusion of the cat's head falsely appearing to be peeking through and in front of the fence. Some of the whiskers on the left side deliberately give away the illusion, to the most observant, as they are both in front of and behind the fence.

It's equally hard and labor-intensive to create an image on the computer as is in a darkroom. Believe me! Jerry Uelsmann

233

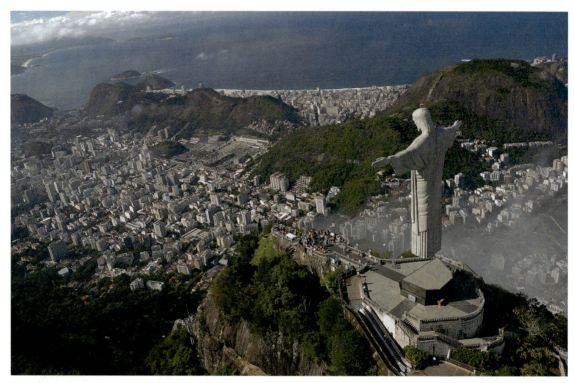

Rio de Janeiro

The giant statue *Christ the Redeemer* atop Corcovado Mountain in Rio is a familiar and famous landmark. It overlooks the city and ocean and is firmly anchored to a platform. By removing some of the upper part of the platform, a space is created between the platform and the statue, making it appear as if the figure was suspended in air or ascending.

The high vantage point from which the photograph was taken reflects the intent of the installation where the Redeemer overlooks and protects the city and its people. It also gives a feeling of the massive size of the statue. Just to the lower right of the statue is a small area of mountain fog.

Myths and creeds are heroic struggles to comprehend the truth in the world. Ansel Adams

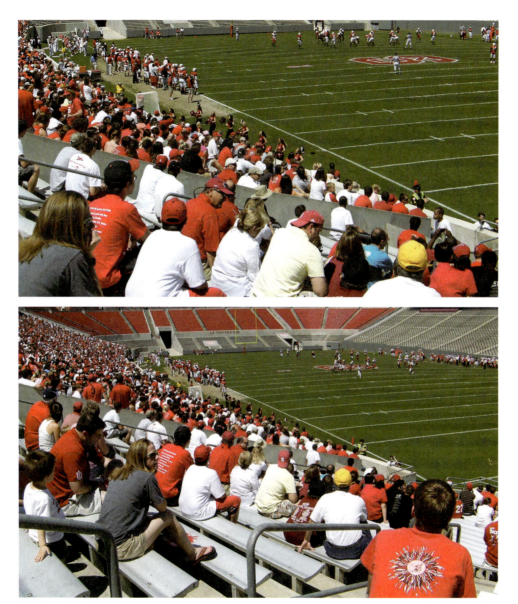

College Football *Richard D. Zakia*

Crop the Image: The photograph at the top of a college football practice game gives the appearance of a large crowd in attendance. The bottom photo is a truer picture.

235

Joey and Luke *Richard D. Zakia*

The main subject and focal point in this lower photograph are the two boys, as they stand in front of a pond looking at the camera. The upper photograph, however, calls more attention to the two brothers and less to the surroundings by cropping a little off the side of the photograph and some off the top.

Vodaphone *Vicki H. Wilson*

Flip the Image: The bottom photograph is the original image. Because it is of a reflection, the letters are reversed, as expected. By flipping it horizontally, the viewer is presented with a contradiction. The letters are now not reversed, as is the racecar, but everything falsely appears normal.

237

Killing Time *David A. Page*

While traveling together in Ireland, one photographer saw this tree and began photographing it. The second photographer, while waiting, also decided to photograph it from a different angle. If the first photographer had not recognized that the tree was worth photographing, and if the second had not decided to kill time while waiting, the image on the right side would never have happened.

Irish Tree of Many Faces *David A. Page*

Mirror Image: Because the tree was asymmetrical, the second photographer chose to photograph only the right side of the tree, with a plan to later duplicate the image, flip it, and match the two parts in order to create his own imagined tree. Although this was done using digital technology, the same technique has been used many times using film and dark-room skills. Where the two sides of the tree met, one face was immediately apparent and many more subtle faces emerged.

The *Irish Tree of Many Faces* title was chosen to challenge viewers to look for more than the most obvious face. The title also pays homage to the widely believed Irish folklore of the "little people" that inhabit special trees in Ireland.

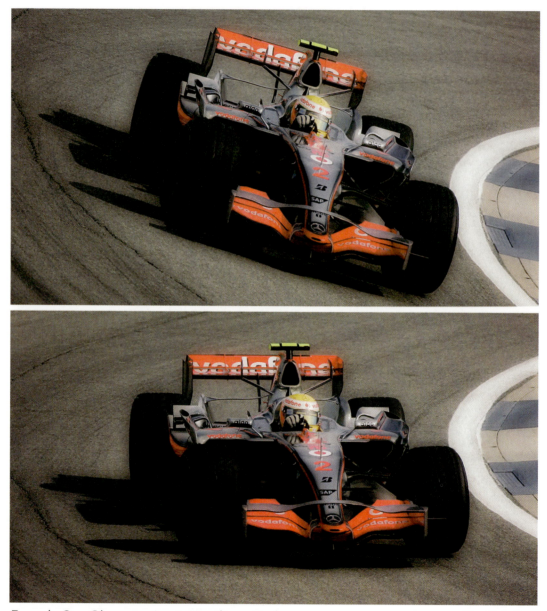

Formula One Champion Lewis Hamilton at Indy *David A. Page*

Tilt the Image: Using Photoshop to tilt the image, as seen here, creates an illusion of greater speed. Tilting can be done in camera, but doing it after capture allows for more flexibility and experimentation.

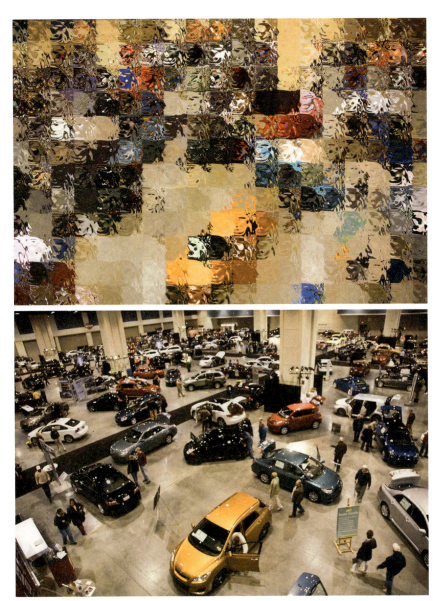

Car Show Quilt *Vicki H. Wilson*

Distort the Image: After-capture software provides the photographer a variety of options for manipulating images in order to change the mood of the original photograph. Enjoy the process of creating something new from an existing good composition.

EXERCISES

Looking

1. The artist Marcel Duchamp in 1919 added a mustache and goatee to the Mona Lisa. The caption, L.H.O.O.Q., is a coded and playful one. Its meaning can be found in Robert Hughes's book *Shock of the New*.

2. Alterations to photography can be traced all the way back to its beginnings. All software such as Photoshop has done is to make it much easier and tempting. In 1924, Man Ray photographed the back of his favorite model Kiki and later added clef marks to suggest a shape of a viola in *Le Violin de Ingres*. In 1980, an ad for Christian Dumas chemises appeared in Italian Vogue, which was a play on Man Ray's photo. Use the Internet to compare Man Ray's photo and the one in the ad. Note the differences. What significant changes do you find?

Photo 1. Mona Lisa.

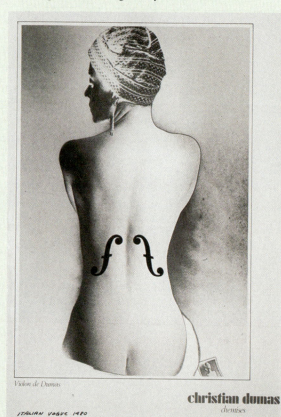

Photo 2. Christian Dumas ad.

3. *Luncheon of the Boating Party*. In this picture of Renoir's famous painting, an uninvited guest with a goatee beard joined the party. He was added, but not by using Photoshop. We are looking at an actual photograph that has not been manipulated. The photograph is of a sculptured rendition of Renoir's painting by J. Seward Johnson, Jr. It was on view at the Corcoran museum in Washington, DC. Attendees were invited by the curator to become part of the sculpture. Many took advantage of this rare opportunity and added themselves to a number of different sculptures on display. The photograph is by David Page.

4. The body of the man holding the frame has been removed (subtracted). That part of the building blocked by his body was then added to the frame. This was not done using any digital software but rather with a manual cut-and-paste method. Ideas are not technology-dependent.

Photo 3. Luncheon of the Boating Party.

Photo 4. Framed. Leslie Stroebel.

APPENDICES

APPENDIX 1
Three Ways to Capture

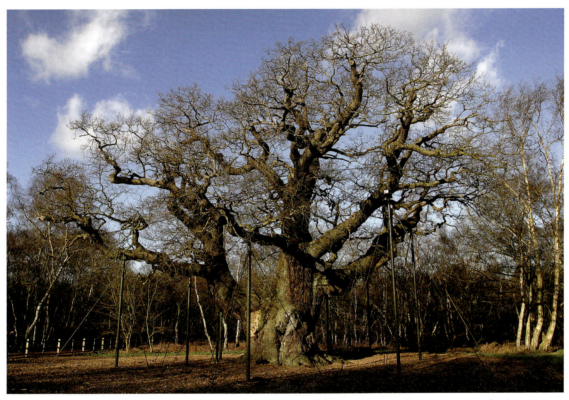

The Major Oak Tree of Sherwood Forest—England's oldest and most famous tree, which is over 800 years old.

Projection Confluence

Introjection Exercise

Most photographers give some thought in advance to what they want to photograph—subjects like flowers, children, landscapes, animals sports, sunsets. Heading out with camera in hand, they search for interesting ways to depict their chosen subject. They consider lighting, background, vantage point, and camera settings to ensure achieving the desired effect before releasing the shutter. Such care to details generally provides good results. But there can be more to making a photograph than just managing the physical aspects.

If you're interested in taking your photography to the next level, this section will challenge you to think beyond the composition techniques you've learned so far. You are invited to step outside your comfort zone and consider your relationship to an inanimate object you are planning to photograph—what the object signifies for you, what it means beyond the aesthetics. Spend time seriously studying the object (your intended subject) and allowing it to reveal itself, as John Sexton demonstrates in his celebrated book of photographs of trees *Listen to the Trees*. One might even consider, as strange as it may seem, talking to the object, becoming one with the object—putting on the qualities of the object as you prepare to photograph it.

As we look more critically at our photographs, especially those by photographers we admire, we may begin to wonder how they prepare themselves before venturing forth with their camera. We touched on this briefly in the "Before Capture" section when we made reference to some photographers meditating before a photo shoot. The following concepts present a more serious and studied way to approach photography.

Photography should be interesting, challenging, and fulfilling. If what follows seems helpful to you, give it some consideration, but if not, realize that you might be able to gain an edge to your photographing experience by taking more time to think about your subject before shooting. Perhaps at a later time you may find that some of what is presented here is worth trying.

Seeing and photographing objects as if they possessed human attributes is a form of *animism*, the belief that animate and inanimate objects—such as rocks, trees, flowers, and the like—possess a soul. Photographer Aaron Siskind, when asked about the meaning of some of his photographs, pondered the question and after some thought responded, "Pressed for the meaning of these pictures, I should answer; obliquely, that they are informed with animism." Ansel Adams said it this way: "The whole world is, to me, very much 'alive'—all the little growing things, even the rocks." Albert Sands Southworth believed that "an artist is conscious of something besides the mere physical in every object in nature. He feels its expression, he sympathizes with its character, he is impressed with its language; his heart, mind, and soul are stirred in its contemplation. It is the life, the feeling, the mind, the soul of the subject itself." Animism is an old idea. Pythagoras and Plato hypothesized that there was an immaterial force present everywhere that animated the universe. How strongly one believes or disbelieves in animism is a personal matter.

What is important is the relationship that the photographer develops with whatever he or she is photographing, be it a person, a tree, a stone, a landscape, a flower, or whatever. The relationship established between the photographer and what is being photographed is a critical one. At least three different approaches can be considered:

- Projection
- Introjection
- Confluence

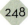

PROJECTION

Here the photographer projects onto the object what he or she wants it to represent or signify. If the object is an oak tree, the photographer may want to photograph it so that it shows its large size, strength, and endurance. If it is an old oak tree, he or she may want to also portray its age.

Each tree is unique, has its own posture and gesture. Each has a quality that makes it an individual. John Sexton

The tree, which moves some to tears of joy, is in the eyes of others only a green thing, which stands in the way. William Blake

INTROJECTION

In this case, the photographer spends time looking at the tree and studying it in a quiet way, attempting to "listen" to what the tree has to reveal. He or she could even talk to the tree: "Hello, tree! I have read a lot about what others have written about you and many things you symbolize; knowledge, life, strength, growth, cosmos, and so on. But I would like to hear directly from you." The photographer then attempts to capture that quality of the tree. What's it like to be a tree?"

When I see a tree ... I can feel that tree talking to me. Joan Miro

I didn't want to tell the tree or weed what is was. I wanted it to tell me something and through me express its meaning in nature. Wynn Bullock

Go not to the object but rather let the object come to you. Thoreau

When I paint, my objective is to show what I have found, not what I was looking for. Picasso

What peace comes from those aware of the voice and bearing of trees!
Trees do not scream for attention.
A tree, a rock, has no pretence, only a real growth out of itself,
in close communion with the universal spirit. Cedric Wright

CONFLUENCE

This is a highly meditative approach in which the tree and the photographer become one and the photograph reveals that intimate relationship. "Greetings, tree! Hope you are feeling well and enjoying the day. You sure do look strong and healthy and I would like to spend some time with you and share common experiences. We both started out as a seed and have grown from that. We depend on water, food and sunlight for life. Your roots are as important to you as mine are to me—where I am from and where I am now. We are connected to our roots. I know that if you were transplanted, you would probably have a difficult time adjusting. We both are part of the same environment and dependent upon each other. What's it like to be out here day and night, every day, smiling at the sun, welcoming the rain, changing with the seasons?"

You come to know a thing by being inside it. You get an inside view. You step into the skin of the beast and that, precisely, is what the masked and costumed dancer does. He puts on the beast. Edmund Carpenter

Object and subject marry and mutually transform each other in the act of knowledge; and from now on man willy-nilly finds his own image stamped on all he looks at. Theilhard de Chardin

Art arises when the secret vision of the artist and the manifestation of nature agree to find new shapes. Kahlil Gibran

Colour possesses me. I don't have to pursue it.... Colour and I are one. Paul Klee

There is one thing the photograph must contain, the humanity of the moment. This kind of photography is realism. But realism is not enough—there has to be vision and the two together can make a good photograph. It is difficult to describe this thin line where matter ends and mind begins. Robert Frank

EXERCISE

Looking

In the Introduction, there was a quote from George DeWolfe on how he uses mindfulness as a way of getting deeply in touch with what he is about to photograph. Minor White would have his students spend time with their eyes closed and meditate in front of what they were going to photograph. When they felt that they had mentally and emotionally connected with the object, they were to open their eyes and click the shutter. They may not have captured what they wanted on the first attempt, but with patience and practice some will find success. This type of photography is difficult and requires much practice and perseverance. You may want to give it a serious try.

In Ansel Adams' book Ansel Adams Trees you will find a number of trees worth looking at and spending time with. There are also short statements by notables such as William Blake, Annie Dillard, Ralph Waldo Emerson, John Muir, Henry David Thoreau, Walt Whitman, and William Wordsworth.

Another book on trees that will provide enlightenment is John Sexton's Listen to the Trees. Again, spend time looking at the trees and you will be rewarded. Georgia O'Keeffe reminded us that we do not spend enough time looking at flowers, and the same can be said in looking at photographs - we don't spend enough time.

Photographing

Find a tree that holds your interest and photograph it. Then spend time with it and have it reveal itself to you. Take a photo from the same spot and compare the two photos. Did you notice a difference? If not, try again. You may even want to spend time mentally talking to the tree.

> The clearest way into the universe is through a forest wilderness. John Muir

APPENDIX 2
Morphics

Self Portrait *David A. Page*

Anamorphic Theriomorphic
Anthropomorphic Zoomorphic
Biomorphic Exercises
Isomorphic

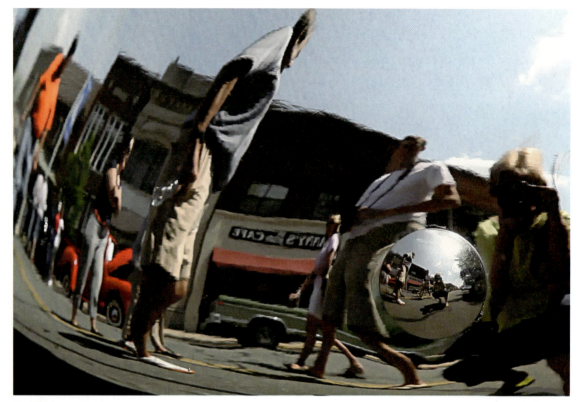

Self Portrait *Vicki H. Wilson*

ANAMORPHIC

This anamorphic image is a straight photograph and has not had any after-capture manipulation. The distorted figures are reflected off of a highly polished chrome car bumper. The curvature of the bumper distorts the background scene and the pedestrians walking by. Notice the extremely long, flat foot and disproportionately short legs on the central figure. A bolt cover attached to the bumper repeats the reflection with greater angle of view and distortion due to its convex shape. Reflective surfaces can provide interesting compositions based on the degree to which they distort, but they can be tricky to photograph, especially if the photographer does not wish to be included in the composition. Chrome is an ideal surface because it reflects true color. Most other reflective surfaces have some degree of innate color that adds a colorcast to whatever it reflects. Although the human eye may not always discern a color change, the camera's sensor or film will.

An anamorphic image is one that is distorted and has to be reformed to be seen properly. Anamorphic images make interesting compositions because they invariably make the viewer question the circumstances by which the photograph was made.

Self Portrait *Richard D. Zakia*

ANTHROPOMORPHIC

An *anthropomorphic* image is one in which objects such as tree trunks, rocks, and the like suggest human characteristics—usually the face. This somewhat triangular stone with its circular "eyes" and wide "mouth" was found washed up on a beach partially buried in the sand after a storm. It can easily be seen as a face and the skin-like coloration adds to the identity. The photograph on page 253 is also an anthropomorphic image.

Two holes—that's the symbol for the face, enough to evoke it without representing it... **Picasso**

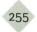

255

Old Man *David A. Page*

Whenever we look at something, we often do not see everything within our field of view, even when the field is small as in a photograph. We select what we want to see. The rest is just background. Such was the case when the photographer was looking at a colorful cliff in Zion Canyon National Park. As he looked at the cliff, something caught his eye, but he did not know what it was. Then, as he studied the side of the cliff, a face of an old man with his tongue sticking out pulled away from the background and became a figure. Often you don't see an embedded image. Then, in a flash, you see it and from then on you can't avoid seeing it.

All attention must take place against a background of inattention. E.H. Gombrich

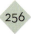

Early Kilroy *William Scanlon*

Here is another case in which the photographer was attracted to the colorful side of a canyon wall. Something caught his eyes and as he studied the scene, a face of Kilroy with his long nose popped out. It is in the center of the photo, just above the middle portion. Above each eye, one can see a patch of red—probably the result of reddish iron oxide leaching out of the sandstone rock. The surface colors are commonly known as "desert varnish." The photo was taken in Utah, in Capitol Reef National Park.

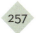

Organic Shapes *Richard D. Zakia*

BIOMORPHIC

Patterns, shapes, and forms that resemble organic living things can be thought of as being *biomorphic*—from the Greek words: bio, meaning life, and morphe, meaning form. The photograph here has curvilinear shapes and appears organic and fluid. There are no vertical or horizontal lines—no sharp edges or angles. The shapes can take on any color or texture. In this photograph, the colors are muted and the actual subject was an oil slick after a rain. Such forms can call attention to the beauty of the natural world. In architecture, the unique buildings in Barcelona, Spain, by Antonio Gaudi (page 264) take on organic forms, as do the many sculptures of Henry Moore.

Whilst part of what we perceive comes to us through our senses from the object before us, another part (and it may be the larger part) always comes out of our minds. **William James**

Maine *Robert Walch*

ISOMORPHIC

Objects and things that have a form similar to something else are said to be *isomorphic*—having the same or equal form. In this photograph simply titled *Maine*, we might assume that we are looking at waves of water splashing against some rocks but we cannot be certain. It also looks like it might be a photograph of flames of fire emanating from the black coal in the foreground and swirling about some dark objects. In any case, the visual ambiguity provides for a challenging look. One can also see near the bottom center of the photograph two dark "eyes" opposite each other, a caricature of a face that provides an eerie feeling.

We can also think of isomorphic as an example of the Gestalt tenant of similarity—things that are similar tend to be seen as related. From a rhetorical point of view, such objects can be seen as a simile—they look like something else, or even as metaphor—having one thing represent another, such as water representing fire.

Hooded Tree Spirit *Carl Chiarenza*

THERIOMORPHIC

When this photograph was on display at a local gallery, some people would only glance at it and then briskly walk away. A few commented later that it was a scary image. *Theriomorphic* images, such as this one, represent beastly characters and have been with us throughout history—gargoyles, which were designed to scare away evil spirits, being but one example.

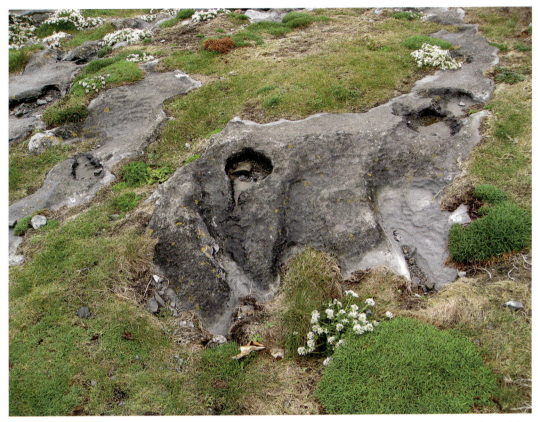

Irish Elephant *Richard D. Zakia*

ZOOMORPHIC

Where is the elephant? If one looks in the upper-righthand corner of this photograph and uses a little imagination, the trunk of an elephant can be seen. Once seen and accepted, the entire elephant emerges from the surrounding green grass. The photographer did not notice the potential shape of an elephant when he took the photo. It was only when he looked at the photo on his computer screen that he recognized the rock elephant. His interest in taking the photo, at a conscious level, was to capture the beauty of the area—the lovely green grass, the outcropping of small white flowers, and the interesting shapes of the embedded gray rocks. Images such as this that resemble animals are said to be *zoomorphic* (pronounced "zoh-morphic").

The mysterious way in which shapes and marks can be made to signify and suggest other things beyond themselves had intrigued me since my student days. E.H. Gombrich

Sometimes when we see nothing much is there to be seen. Corinne Whitaker

EXERCISES

Looking

1. It has been said that St. Patrick rid Ireland of all its snakes. Can you find the one still lingering in this photograph? Hint: it has its mouth wide open as if preparing to devour something.

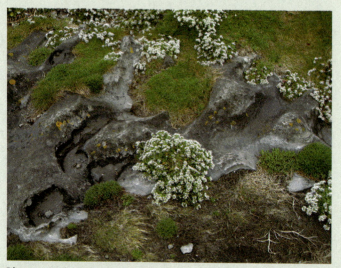

Photo 1. Irish Snake. Richard Zakia.

2. Georgia O'Keeffe loved painting flowers and remarked that we don't spend enough time looking at them. Peter Wach does. This photo was taken at the Rockefeller Park Greenhouse in Cleveland, Ohio. He writes, "During bloom time the orchids draw my attention to their delicate facial features including this lady-slipper variety, which appears to be wearing a fancy Victorian Bonnet."

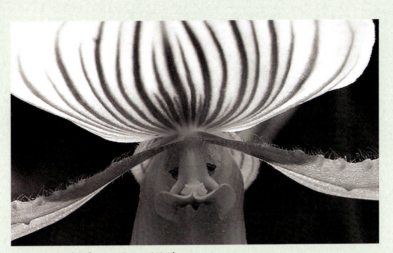

Photo 2. Lady Slipper. Peter Wach.

3. The famous Casa Batllo building in Barcelona by the Spanish architect Antoni Gaudi (1852–1926) is a wonderful and unique example of biomorphic architecture. He was affiliated with the Modernist (Art Nouveau) movement and was inspired by nature at an early age. His unprecedented originality was, like all new art, ridiculed by his peers. Time, however, has proven him to be one of the most creative and original architects.

Photo 3. Casa Batllo, Gaudi. Manuel Trujillo.

4. Two prominent photographers, André Kertesz and Bill Brandt, created some interesting anamorphic images in their time. Look them up on the Internet and spend some time with them.

Photographing

1. Look for some reflecting nonflat surfaces and photograph yourself being reflected to create an anamorphic image. Be playful.
2. Spend time looking at rock formations, tree trunks, flowers, and such to discoverer and photograph interesting forms (morphics). Walk the beaches looking for interesting rocks, shells, and driftwood.

APPENDIX 3
Golden Mean (Golden Section)

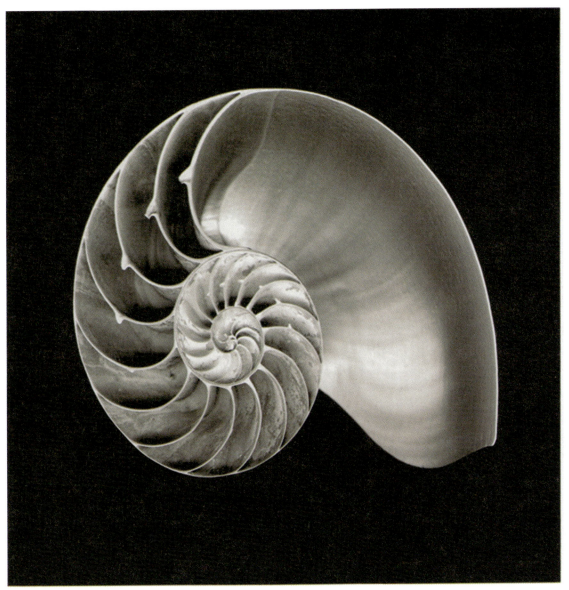

Nautilus *Thomas L. McCartney*

GOLDEN MEAN (GOLDEN SECTION)

The *Golden Section* refers to a rectangle of any size that has a length that is 1.62 (1.618) times that of its width. A practical application to the Golden Section is in making a decision on how to crop a photograph. The closer the cropped print is to the Golden Mean, the more pleasing the print size should be. In photography, for example, with a 3 × 5 inch print, the 5-inch side is 1.66 times longer than the 3-inch side. As a ratio, it is written 5:3. Rectangles with such a ratio are considered to be pleasing to the eye. Prints that are 4 × 5 inches, 8 × 10, and 16 × 20 have a ratio that is less than the Golden Mean, being only 1.25. Once-popular 35 mm film was 24 × 35 mm and had a ratio of 1.46.

The Golden Section has a long history going back to early Greek and Egyptian times and has been used in art and architecture for centuries. The Parthenon and the Egyptian pyramids serve as examples. It is also found in growth patterns of nature, curves of sunflowers, seashells, and galaxies. The Golden Section is also known as the Golden Mean and the Golden Rectangle, and in Egypt it was know as the Sacred Ratio. On the previous page is the cross-section of a nautilus shell, showing the expanded spiral growth pattern.

Fibonacci (1180–1250), an Italian mathematician, had a passion for numbers and discovered a series of numbers that describe not only the expanding growth pattern of things in nature but also the Golden Section. The numbering sequence is amazingly simple—0, 1, 1, 2, 3, 5, 8, 13, 21 …. The numbers are arrived at by adding the sum of the previous numbers, such as $0 + 1 = 1, 1 + 1 = 2, 2 + 1 = 3, 3 + 2 = 5$ and so on. By taking the ratios of the adjoining numbers, one finds that they follow the golden section closely:

$3/2 = 1.50$
$5/3 = 1.66$
$8/5 = 1.60$
$13/8 = 1.62$
$21/13 = 1.62 (1.615)$

As the numbers continue, they approach the exact ratio for the Golden Section, 1.618. Looking at the series of ratios in the Fibonacci series, prints cropped to 3 × 5, 5 × 8, 8 × 13, 13 × 21, and so on would meet the Golden Section ratio.

In the 1800s, Gustav Fechner, a German experimental psychologist, did a study to find out the size preference of paintings. He asked a number of people to indicate their choices of rectangles of different formats and found that their preference was for rectangles with proportions (ratios) near the Golden Mean. However, he found out later that measurements of hundreds of paintings in museums, on average, had proportions of 4:3 (1.33) for horizontal and 5:4 (1.25) for verticals.

As in many situations, rules should be considered guidelines to assist you in your decisions. The photograph should be sized and framed to a ratio that works well for the print. For example, a panoramic print would not fit well into a Golden Mean ratio.

APPENDIX 4
Aspect Ratio

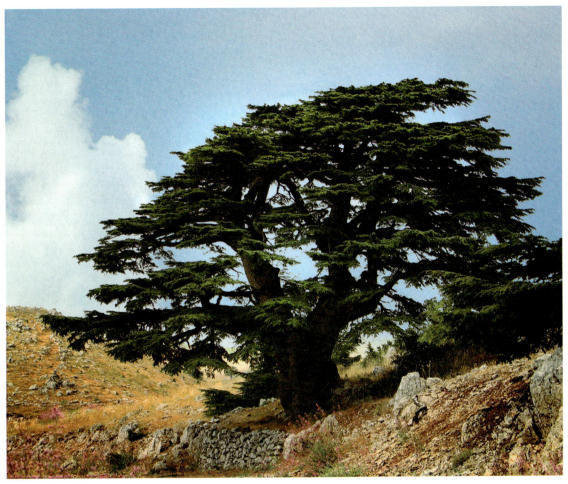

Cedar Tree, Lebanon

ASPECT RATIO

This photograph of a cedar tree has an aspect ratio of 1:1.22. It falls short of the Golden Mean ratio of 1:1.62.

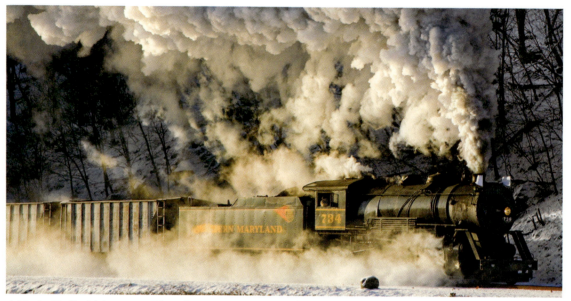

A Train Called Mountain Thunder *David A. Page*

The aspect ratio is the relation of height to width in the final image, or a frame of a camera's image capture area. It is expressed in whole numbers and separated by a colon. For example, both 4×5 and 8×10 cameras have a shooting aspect ratio of 4:5. A standard 35mm film camera which has a 1 inch by 1.5 inch image capture area, is expressed as a 2:3 aspect ratio, which is perfect for a 4 inch × 6 inch print. When having prints made at a commercial facility, it is important to match the aspect ratio of the original file or negative to the intended printed image. For example, if someone has an 8×10 print made from a 35mm negative or file, the long ends of the image will be cropped off. To preserve the full-frame image of the original file, an 8×12 print is needed. When 8 and 12 are divided by 4, the resultant 2 and 3 become the same aspect ratio (2:3) as a 35mm camera's format. With digital cameras the aspect ratio will vary depending upon the model of the camera.

Some photographers mistakenly believe that the photograph, once taken, should never be cropped. That fallacy is letting a tool (the camera) determine the composition of the final image. Even though the eye will naturally try to compose to the aspect ratio of the camera's viewfinder, the subject and the photographer's intentions should be the ultimate factors in deciding the final composition.

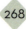

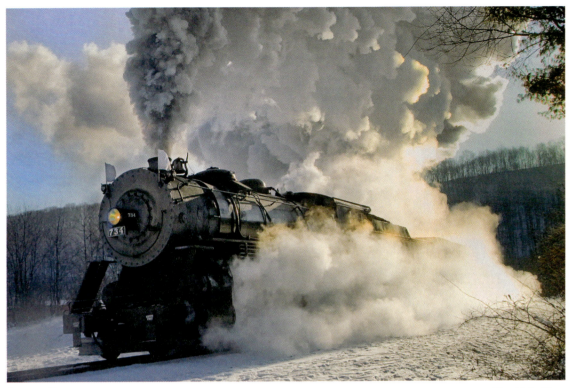

Steam Power 2010 *David A. Page*

Both images on these pages were taken with the same camera on the same day. The image to the left requires a 1:2 (panoramic) aspect ratio in order to dramatize the Mountain Thunder's ability to haul heavy loads up the steep Allegheny Mountains. Cropping for a 1:2 aspect ratio also places greater emphasis on the subject by deleting unnecessary visual elements from the image. A 1:3 ratio would have allowed more of the train to show, but it would also reduce the size of the image on the page. As the photograph on the right is more about the power of steam engines in general, cropping to a more standard 2:3 aspect ratio worked better. That cropping emphasizes the steam billowing out of the stacks and under the engine and obscures most of the train and the engines identifiers, making the image all about steam power in general. The same subject captured with the same camera but finalized by using different aspect ratios makes two powerful but different presentations.

To increase the 1:1.45 aspect ratio of the bottom photo to that of the Golden Mean (upper photo), the sky was slightly cropped. Some might prefer the top photograph to the bottom one, even though the difference is small.

APPENDIX 5
Digital Transformations

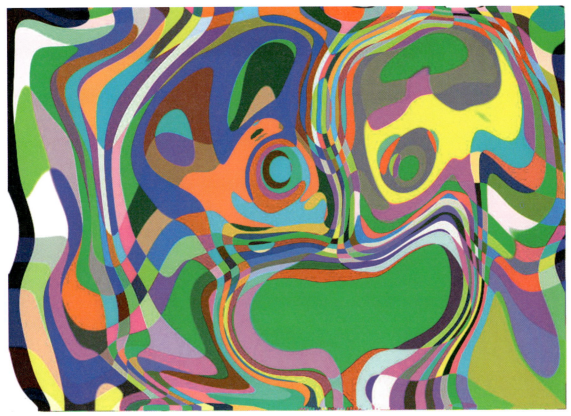

Party Time *J. Thomas Bullington*

From Real to Surreal

Party Time is a transformation from the multiplicity of 459 small squares in the color test target on the following page.

I1 TC 9.18 RGB Testchart part 1

Photographers have always been good at borrowing and using new technologies. Film photographers experimented with a variety of films to create interesting and unusual images; false color film, camouflage detection film, aerial film, infrared film, high-contrast lithographic film, and so on. When computers came on to the scene, photographers began using Adobe Photoshop, which was originally intended for the printing industry, not photography. It was not until Photoshop 2.5 was introduced that Dodge and Burn tools were offered. Now it is safe to say that the Photoshop family of programs is designed primarily for photographers.

Most recently, a new form of imaging has been taking place. The photographed subject is manipulated digitally and often obscured, resulting in a new hybrid image that is totally unrelated to the original subject. The composition becomes the primary subject. Several software programs can be used to create the hybrid: Photoshop, NIK, Alien Skin, Auto FX, onOne, and others. Corel and others make stand alone imaging products that photographers often use to modify and create new images from photographs.

Almost a hundred years ago, photographers under the influence of impressionist painters started a comparable movement that they called *pictorialism*. Its hallmarks were soft focus and mechanical manipulation of the photochemical and optical processes. Like the visual experimenters of today, they put less importance of the actual scene being depicted than the composition of the finished picture. The movement died out as people tired of the increasingly overdone manipulation, which failed to further enrich the medium.

When photographers are asked by a viewer after seeing their image, "What is it?" they might easily reply, "What would you like it to be?"

A single vertical line of pixels in the feather image was selected and then duplicated many times to form a column with horizontal bands, capturing the feeling of the windows of a skyscraper. Each column except the third was formed from a vertical line of pixels in the background along one of its edges. The third is from another part of the image to add the yellow color. Duplicating and flipping over a strip of the image on the right side increases the size of the black void at the top, which adds depth and balances the composition.

Neon City 2 *J. Thomas Bullington*

I am interested in using a fusion of traditional print-making, graphic design and painting with the modern digital world of the computer and digital output to produce images: thus joining ideas, materials and techniques old and new to form a single entity. J. Thomas Bullington (www.jthomasbullington.com)

Untitled 23 *Vicki H. Wilson*

FROM REAL TO SURREAL

The photo at the lower right was cropped to 5 percent of its original size. The Photoshop filters Lens Correction and Ocean Ripple were applied. Color saturation and contrast were increased and the image was rotated for the final composition.

My goal is to see beyond the limits of the camera lens, to transition the real into the surreal. When composing in the camera I concentrate on the interaction of light, color and shape, paying little attention to the actual subject. Abstract photography does what abstract painting cannot do; it bypasses the blank canvas phase as the camera lens creates the genesis of the abstract composition. Vicki H. Wilson (www.photoabstracts.com)

BIBLIOGRAPHY

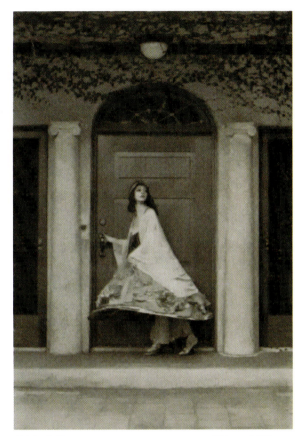

Girl at Door, 1917 *Edward Weston*

Adams, Ansel. *Examples: The Making of 40 Photographs*. Ansel Adams, 1989.

Adams, Robert. *Why People Photograph*. New York: Aperture, n.d.

Arnheim, Rudolf. *Art and Visual Perception*. Berkeley: University of California Press, 1974.

Berger, John. *Ways of Seeing*. London: BBC/Penguin, 1987.

Bullock, Wynn. *The Enchanted Landscape, Photographs 1940–1975*. New York: Aperture, 1999.

Bush, Janet Swan. *Ansel Adams, Trees*. New York: Little Brown, 2004.

Cartier-Bresson, Henri. *The Mind's Eye*. New York: Aperture, n.d.

Dover, *Great Photographs From Daguerre to the Great Depression*. Mineola, NY: 2008 (139 royalty-free photographs on a CD-ROM and book).

Eastman Kodak. *More Joy of Photography*. New York: Addison-Wesley, 1981.

Eastman Kodak. *The Joy of Photography*. New York: Addison-Wesley, 1979.

Freeman, Michael. *The Photographer's Eye.* Boston: Focal Press, 2007.

Greenough, Naomi, et al. *The Art of the American Snapshot, 1888–1978.* Princeton, NJ: Princeton University Press, 2007.

Jeffrey, Ian. *How to Read a Photograph.* New York: Abrams, 2008.

London, Barbara, Jim Stone, John Upton. *Photography.* New Jersey: Prentice Hall, 9th edition, 2007.

Marien, Mary Warner. *Photography: A Cultural History.* New York: Prentice Hall and Abrams, 2002.

Myers, Jack Fredrick. *The Language of Visual Art.* Chicago: Holt, Rinehart and Winston, Inc., 1989.

Newhall, Beaumont. *History of Photography: From 1839 to the Present.* New York: Bullfinch, 5th edition, 1982

Newman, Arnold. *Arnold Newman: Artists' Portraits.* Boston: David R. Godine, 2010

Porter, Eliot. *The Color of Wilderness.* New York: Aperture, n.d.

Rosenblum, Naomi. *A World History of Photography.* New York: Abbeville Press, 2008.

Sammon, Rick. *Digital Photography Secrets.* Indianapolis, IN: 2009

Steichen, Edward. *The Family of Man.* New York: The Museum of Modern Art, 7th Printing, 1997

Steiner, Ralph and Caroline Steiner (Eds). *In Spite of Everything, Yes.* New Mexico, University of New Mexico Press, 1986

Szarkowski, John and William Eggleston. *William Eggleston's Guide.* New York: Museum of Modern Art, 2002

Szarkowski, John. *John Szarkowski Photographs.* New York: Bulfinch Press, 2005

Szarkowski, John. *Looking at Photographs.* New York: Museum of Modern Art, 1973.

Turner, Pete. *The Color of Jazz.* New York: Rizzoli, 2006.

Zakia, Richard. *Perception and Imaging—Photography, A Way of Seeing.* Boston: Focal Press, 3rd edition, 2007.

INDEX OF QUOTATIONS

INDEX OF QUOTATIONS

INDEX